IMAGES
of America

NORTH BERWICK

D1319361

IMAGES
of America

NORTH BERWICK

North Berwick Historical Society

ARCADIA
PUBLISHING

Published by Arcadia Publishing
Charleston, South Carolina

Printed in the United States of America

Library of Congress Control Number: 2012945488

For all general information, please contact Arcadia Publishing:
Telephone 843-853-2070
Fax 843-853-0044
E-mail sales@arcadiapublishing.com
For customer service and orders:
Toll-Free 1-888-313-2665

Visit us on the Internet at www.arcadiapublishing.com

The members of the North Berwick Historical Society dedicate this book to our late president, Royal Cloyd. He was a bigger-than-life figure with an amazing repertoire of talents, which he tirelessly used to promote the historical society and to preserve the history of his adopted town of North Berwick. His contributions go beyond description.

CONTENTS

ACKNOWLEDGMENTS

There were many individuals who contributed photographs, postcards, and stories throughout this process for which we are very grateful. Without their help, this publication would not have been possible. Regretfully many wonderful pictures could not be used but are now a part of the historical society's expanding collection. Unless otherwise noted, all images appear courtesy of the North Berwick Historical Society. We particularly want to recognize Ralph Guptill for his extraordinary and tireless work gathering photographs, interviewing folks, and editing much of what this volume presents. Also a special thanks goes to Astrida Schaueffer for helping date many photographs. We ask the indulgence and understanding of our readers should there be errors and omissions.

INTRODUCTION

The North Berwick area was originally inhabited by the Newichawannocks (the Native American name for Berwick) with many living close to Bauneg Beg Lake. The first white men to cross the area were likely fur trappers and those looking to harvest massive pines (often standing 1,500–2,000 feet tall) from the vast virgin forests. The forests and streams teamed with bear, deer, and fox. But the most precious pelt came from the beaver. Beaver had already been in use for hats throughout Europe since the Middle Ages. By the 16th century, however, the animals were nearly extinct in the western part of the continent. Because of this, the discovery of a new source was not only timely, but it also opened up a whole new market for European goods at great profit. Indians traded furs and corn and sold land to the colonists, and in spite of several notable and sometimes violent confrontations, colonists and Native Americans lived fairly peacefully side-by-side. In large part, this was because North Berwick had such a strong Quaker community.

Sir Fernando Gorges of England was given a charter to the colony of Mayne (Maine) by King Charles I of England around 1625. Originally a part of Kittery, the area was first settled by the English in 1693. It was set off from Kittery in 1713 as part of Berwick, named for Berwick-upon-Tweed on the Angle-Scottish border. North Berwick separated from Berwick in 1831 and was incorporated as its own town.

Even as early Maine settlers strove to establish a way of life and to develop solid and peaceful communities, several disruptive forces shook the stability of their society. In addition to conflicts with the native people, one of the most significant was the environment itself. Not only were Maine winters colder than England's but were also markedly colder than those of present-day Maine. Luckily, unlike many surrounding areas, North Berwick was blessed with good soil, and once the dense forests were thinned, farming thrived.

Among the earliest residents, we find the names Goodrich, Guptill, Chadbourne, Frost, Purington, Buffum, and Morrell. Chadbourne held the first deed in the record of Maine. John Morrell, a Quaker during the time when the Society of Friends was persecuted by king and churches and in its missionary years, was the second. When voters in Kittery were allotted 100-acre checkers of land in the future North Berwick area, Morrell not only claimed his family's shares but also expanded his holdings by purchasing checkers from willing Kittery citizens. Before long, John and his sons owned half the land in North Berwick. He erected a log cabin in 1690. It is thought that this structure burned in the mid-18th century. At that time, he built another house, which is known as the Morrell-Sherburne House, and is home today to the North Berwick Historical Society.

Women's economic contributions were fundamental to their families' well-being and to the development of North Berwick. They were the growers, gatherers, traders, preparers, and preservers (salting, smoking, drying, pickling, and root cellaring). Women had to clothe their families and needed to be skilled at needlework. Numerous other household tasks also demanded attention, including laundry and mending, feeding the livestock, gathering kindling, and, the most time-consuming, raising children. Note that it was not uncommon for a couple to have a dozen!

The Revolutionary War was about many things, and Eastern white pine was one of them. Great Britain had depleted its forests by the 17th century. To supply its appetite for timber for wooden ships, Great Britain looked to the tall, straight white pines of the colonies, especially the old-growth pines, which were perfect for the masts of sailing ships. Since all of New England was considered "Crown Land" of the British Empire, the king took control of the tallest and largest of these great trees. Every winter, the king's royal surveyors would flag white pine trees with a mark called the "King's Broad Arrow." The colonists were not allowed to cut down these trees for their own use, which greatly upset the those who made a great deal of money from the wood products they produced and sold. Needless to say, this resulted in numerous skirmishes between the local settlers and the British; the conflict became known as "the White Pine War." North Berwick resident John Frost refused to allow cutting on his property, challenging the White Pine Acts in court in 1734 by suing mast agents for trespass. He won and was awarded damages. It was the first case of a colonial court refusing to enforce an order issued by the crown. Some historians believe that denial of use of these trees was as instrumental as the taxation of tea in bringing about the American Revolution.

Peter Morrell, a slaveholder through inheritance from his father, loosened conventional restrictions on his two slaves by allowing them to make choices by way of forming conditions for their freedom. By 1777, following the manumission of eight other slaves, the Dover-Berwick Friends Meeting abolished slavery. (Here, things progressed rather more rapidly than in the rest of America.) For Samuel Buffum, abolition could not wait for the slow process of persuasion. He became a militant garrison abolitionist and was a friend of Sojourner Truth and Frederick Douglass. This group was also a champion of women's rights.

Development was spurred in 1842 by the arrival of the Portland, Saco & Portsmouth Railroad, which was joined by the Boston & Maine Railroad in 1873. North Berwick became a railroad hub from which its manufactured goods were shipped. Also loaded aboard the boxcars were barrels of apples and blocks of ice cut from Cider Mill and Bauneg Beg Ponds. As the town matured economically, occupations diversified. Blacksmiths, carpenters, and millwrights were joined by coopers, wheelwrights, shoemakers, tailors, and other artisans related to an agrarian society.

In 1834, the Maine Legislature incorporated Lang, Hill & Company to manufacture woolen blankets. Renamed the North Berwick Company, by 1850 its principal owner was "Friend" William Hill, and the company was best known for making blankets for Civil War troops. In addition to blankets, the factory had 40 looms turning out 1,500 yards of flannel each day.

Wooden plows were the norm before local farmer William Hussey designed a cast-iron plow in 1835. Many would agree that no single agricultural implement has yet surpassed the plow in importance. The Hussey Plow Company evolved into the Hussey Manufacturing Company and, eventually, the Hussey Seating Company. Today, they manufacture seats for auditoriums and bleachers for stadiums and other spectator facilities. In 2003, Hussey was honored as Maine's oldest family-owned business.

One

AT HOME

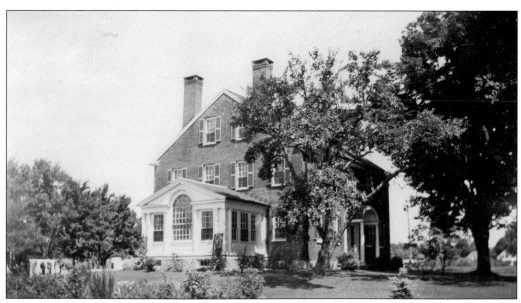

Dr. Jairus Came built this brick mansion on Elm Street in the 1800s. In 1831, he wrote the petition and obtained signatures to divide Berwick, allowing North Berwick to become a separate entity. In the 1890s, Judge Elvington Spinney purchased the house. Judge Spinney was a noted lawyer who ran for the US Congress in 1928. Older town residents still refer to this home as "the Spinney house."

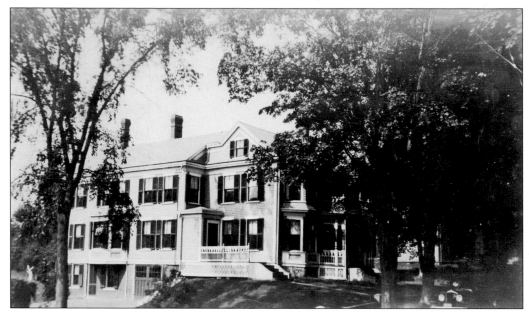

This house stands on the banks of the Negutaquet River. A nearby dam pools the river water here, and for years after the Fry family lived here, local residents have called it "the Frys." Until recent years, it was a favorite spot for ice-skating and bonfires in the winter. (Courtesy of Thomas Wellwood.)

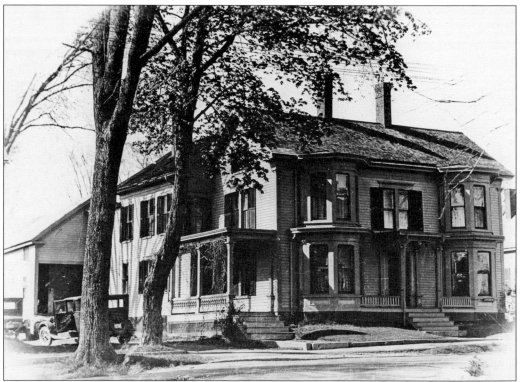

This stately home was built in a style common in North Berwick in the late 1800s. The vehicles in the driveway date this picture to the early 1900s.

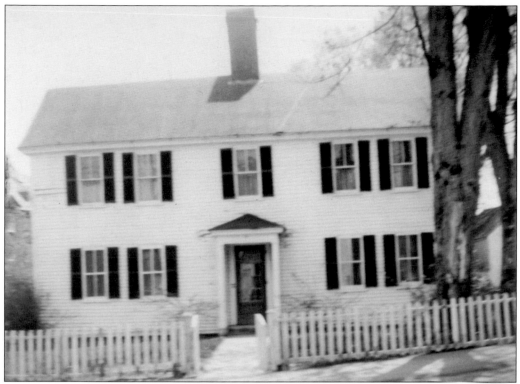

Thomas Hobbs Hostelry was built in 1763. This house on Wells Street is in the National Register of Historic Places and is owned by the Pickett family. Robert Pickett (1917–2011), a direct descendant of Thomas Hobbs, had a vast knowledge of North Berwick's history. He and his wife, Edith Chadbourne Pickett, lived here for 60 years. (Courtesy of Andrea Lovell.)

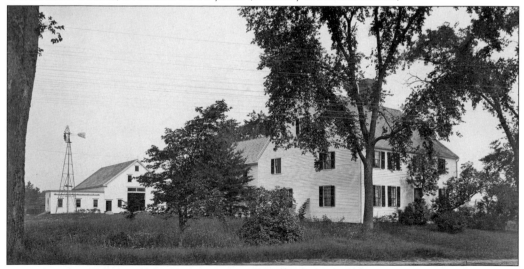

In 1765, Joshua Buffum built this house, located at the corner of Elm Street and Buffum Road. It is one of the oldest houses in North Berwick. After several generations, Charles Buffum sold the house to his sister Phebe and her husband, Issac Varney, who ran a felt mill near this home. When the railroad came through town and crossed Elm Street, the crossing came to be known as Varney Crossing.

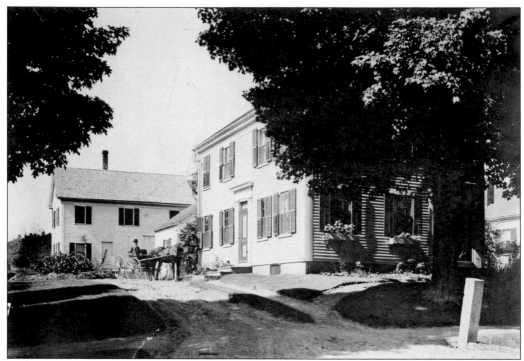

This house on High Street was built by Samuel Buffum and remained in the Buffum family until Samuel's daughter, artist Edith Buffum, died in 1978. Samuel wrote the booklet "Historical Sketch of North Berwick" for the town's centennial in 1931.

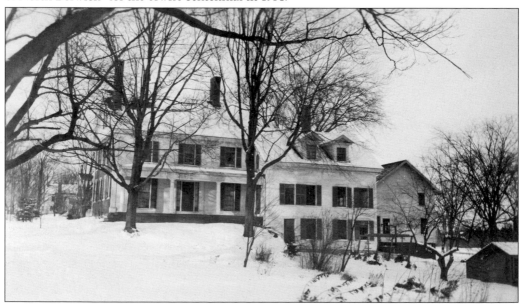

The Fernald-Small house was built in 1830. The names Hercules, Oliver, and John Fernald can all be found in many of the old records of North Berwick. Oliver was born in North Berwick in 1799 and died here in 1883. The bricks for the structure were made in North Berwick by the Butler brick business. In 1936, Mariam Small and her brother bought this house and lived here for many years. It is now owned by Audrey Beals. (Courtesy of Audrey Beals.)

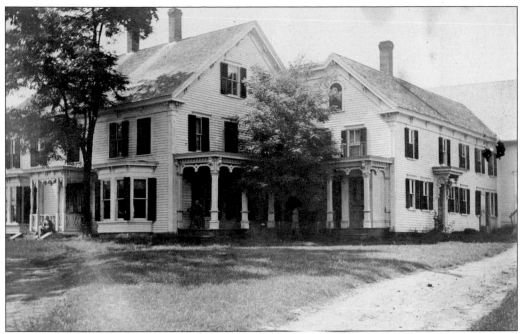

Brackett Hall's house on Cabbage Hill has the distinct look of two houses joined together. Brackett purchased the farm of 100 acres in 1842 from Joshua Jenkins and continuously added land, which eventually totaled 600 acres. He grew acres of cabbages, thus the name Cabbage Hill. (Courtesy of Sherry Kojek.)

This house on Maple Street was moved here in the early 1900s from Elm Street, where it sat near the Negutaquet River. George Littlefield and later his son Granville owned the house, which is now lived in by the second generation of the Morse family. (Courtesy of William Wyman.)

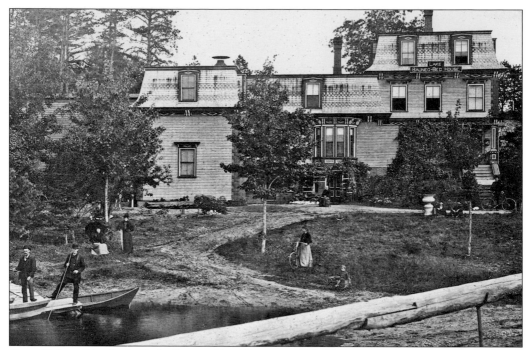

Daniel Morrell built the Lake Bauneg Beg House in 1875. This mansard-roofed Victorian home served as an inn for many years, and Daniel and wife, Harriet (née Randall) Morrell, managed it. Many local family reunions were held here, and several guest books, listing well-known names of the area, are still in existence today. (Courtesy of Shelia Jordan.)

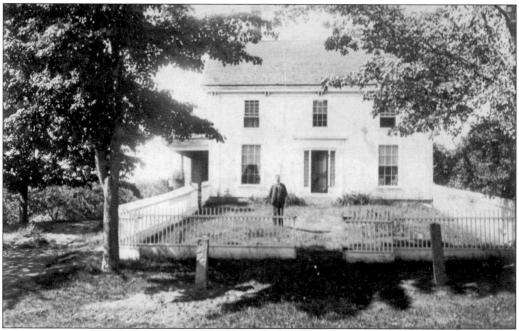

This house on Lebanon Road was built by Tristram Johnson and is one of two houses the Johnson brothers built beside each other. The man standing on the lawn is Tristram's son Joseph Goodwin Johnson. These houses shared the same well until the 1980s. (Courtesy of William Wyman.)

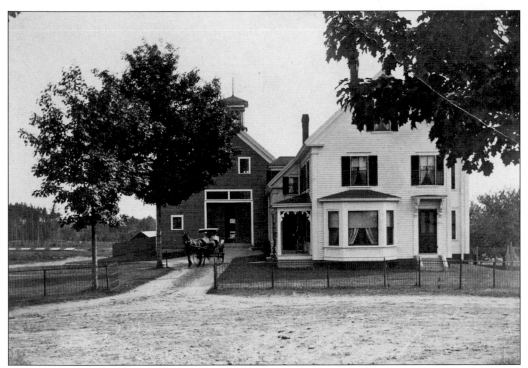

Charles Neal, son of John Neal, built this farmhouse on Buffum Road in the late 1880s. It now sits off Route 9. Charles was a farmer who raised cucumbers and a variety of flower seedlings. In his daughter Geneva's memoirs, penned in her 80s, she wrote of the hard work as well as the joyous times, such as riding to school in the horse and buggy, covered with blankets and warmed with hot soap stones on cold days. (Courtesy of Karen Summers.)

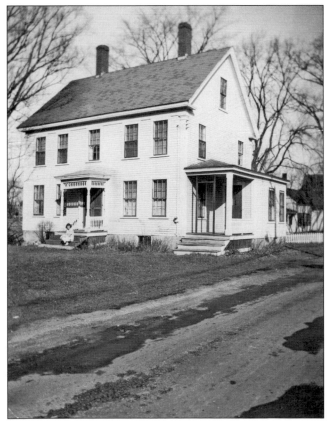

The First Baptist Church parsonage originally sat on the corner of Church Avenue and Main Street in front of the church that burned in 1906. Before rebuilding the church, the parsonage was moved where it stood behind the church. It was torn down in the 1960s to make room for a church addition and parking lot. (Courtesy of Rev. Wayne and Elsie Porter.)

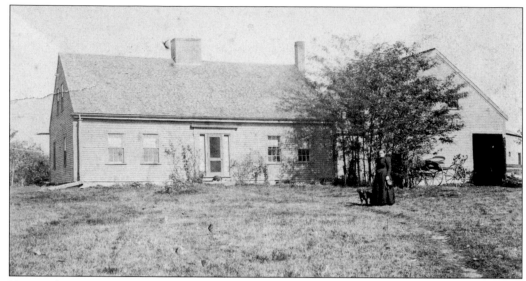

Here is the Morrell-Sherburne House when it stood on Wells Street. Constructed around 1750, this was the second house built on this spot by John Morrell. Some of the inside beams appear to be from the original log cabin; the main room has a large brick fireplace with an oven on the side. The house was moved in 1991 to Old County Road and is now the home of the North Berwick Historical Society.

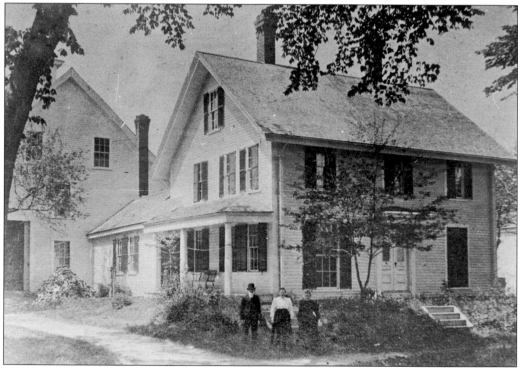

This house stood where Cumberland Farms now stands and was originally owned by the Snow family. It was torn down in the 1950s to make way for a new A&P Building. That building was later torn down for the Cumberland Farms store. The Snow family is one of the oldest families in North Berwick; most of them served as merchants.

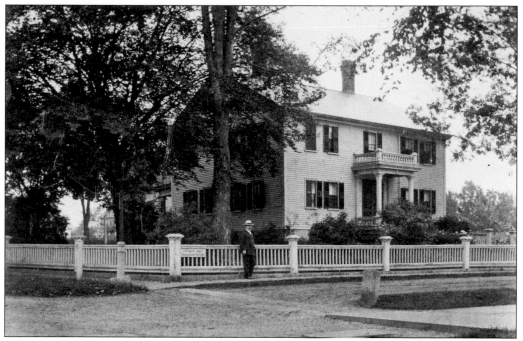

Woolen Mill's superintendent's house carried the Weymouth name since William Weymouth lived here around the turn of the 20th century. This was home to many superintendent families with names such as Spaulding, Sykes, Hartshorn, and Hunt. George Bouldry was the last mill superintendent to live here. The final tenants, before it was torn down to build the Kennebunk Savings Bank, were George Hodgkins's family members.

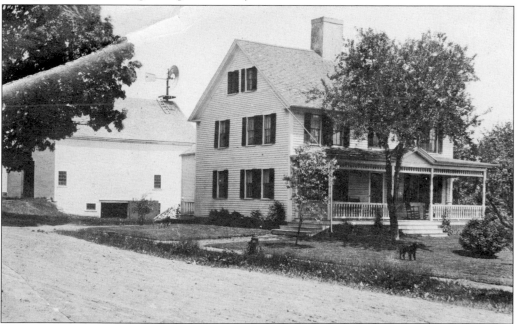

Elijah Neal built this Colonial-style house on High Street in 1811 for his family of 11 children. It was home to five generations of Neals until the 1960s. Note the weather vane made in the Neals' blacksmith shop. (Courtesy of Thomas Wellwood.)

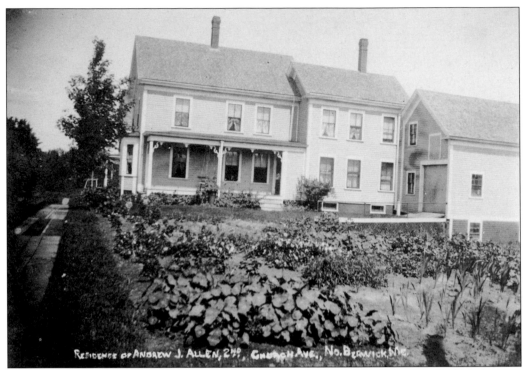

The inscription written on this postcard is "Residence of Andrew J. Allen, 2nd, Church Ave., No. Berwick, ME." (Courtesy of Thomas Wellwood.)

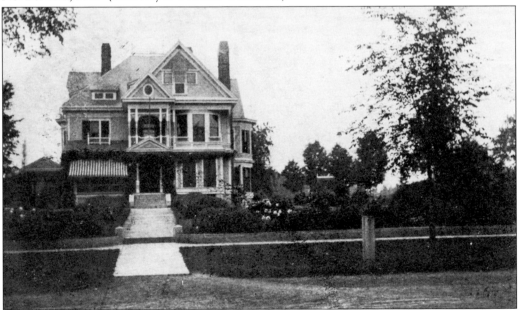

The Hurd Manor sits majestically above the town. Mary Hill's father built the original house, Maplewood Manor, for her when she married her first husband, William Hobbs, in 1870. In 1887, Mary moved her original house back from the road and built this beautiful Victorian mansion, where she and her second husband, Daniel Hurd, lived out their days. Today, Benjamin and Sally Gumm own it. (Courtesy of Thomas Wellwood.)

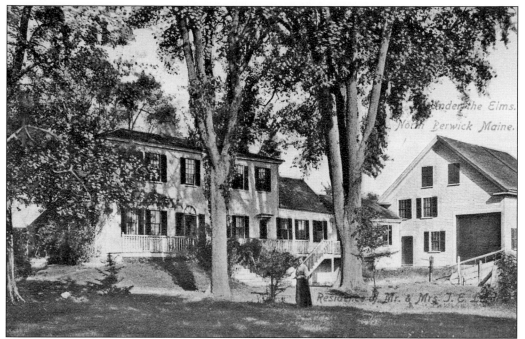

The Elms, a flat-roofed Federal-style house, sits beside the Negutaquet River on Elm Street. Samuel Buffum Sr. erected it in the early 1800s for his 10-member family. Donald and Lois Tucker now own it. (Courtesy of Thomas Wellwood.)

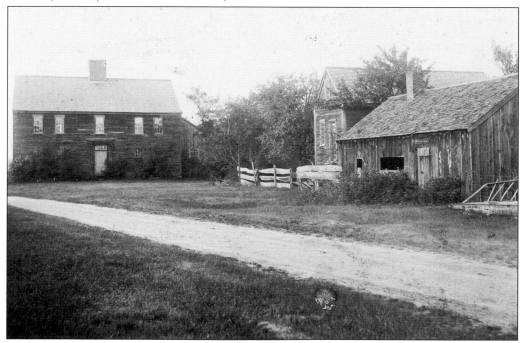

Winthrop Morrell built this home for his bride, Susannah Lewis, in 1769. In 1969, Jerry Ballentine bought and restored this old colonial house. Seen in the picture are the one-room schoolhouse and a blacksmith shop, both of which are gone now and replaced by a barn. (Courtesy of Thomas Wellwood.)

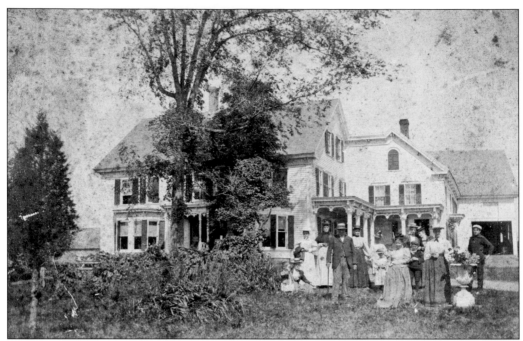

This is a turn-of-the-century picture of the members of Brackett Hall's family in front of their Cabbage Hill house. (Courtesy of Shelly Kojek.)

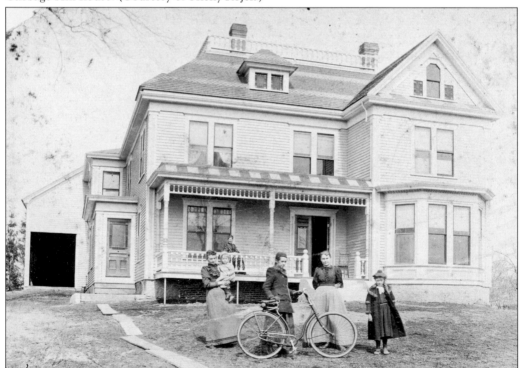

Dr. McCorison built this house on Wells Street. He was described as a real country doctor, who rode to see his patients in his horse and buggy. This picture is dated 1896. Edith Buffum stands with her bicycle, which was the first girl's bicycle in North Berwick.

This house stands across from the Lake Bauneg Beg House. It is said that Daniel Morrell constructed this house before he built the Victorian home across the river. The inscription on this postcard reads, "H.R. Morrell," which stands for Harriet Randal Morrell, Daniel's wife.

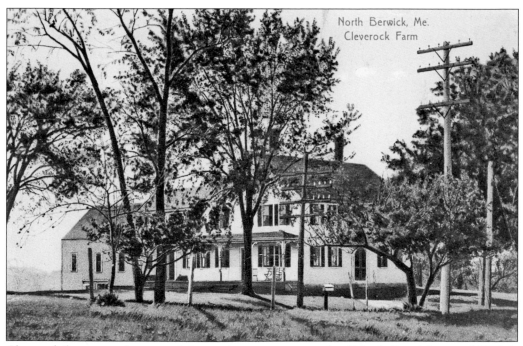

Cleverock farm was a homestead depicted on many postcards of North Berwick around 1907. It is not known if it still exists today. (Courtesy of John and Gerry Randall.)

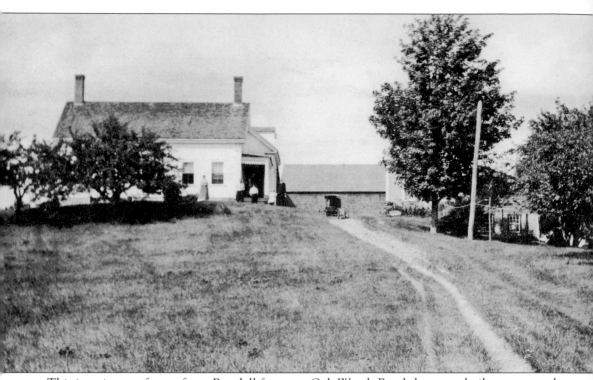

This is a picture of one of two Randall farms on Oak Woods Road that were built next to each other probably in the late 1700s. (Courtesy of John and Gerry Randall.)

Two

FAMILIES

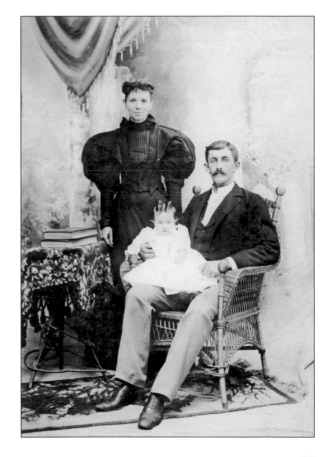

This family of three poses for a photographer around the turn of the 20th century. The leg-o'-mutton sleeves, which were all the fashion in the mid-1880s, grew in size each year until they went out of favor about 1906. (Courtesy of Melissa Johnson Pierce.)

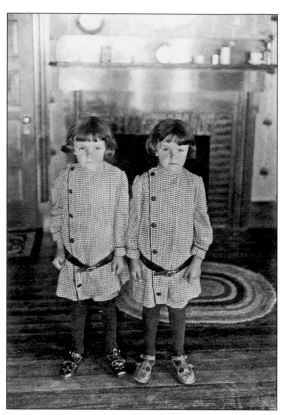

These twins, Max and Maurice Pickett, were brought up with their brother Robert on Maple Street in their mother's family home. (Courtesy of Andrea Lovell.)

Because pictures of families in the late 1800s were few and far between, it was important to have photographs taken at large family reunions, such as this one. Note the large plaid bow on the boy in the front row. This accessory was a typical part of an outfit for young boys in the 1890s. (Courtesy of Melissa Johnson Pierce.)

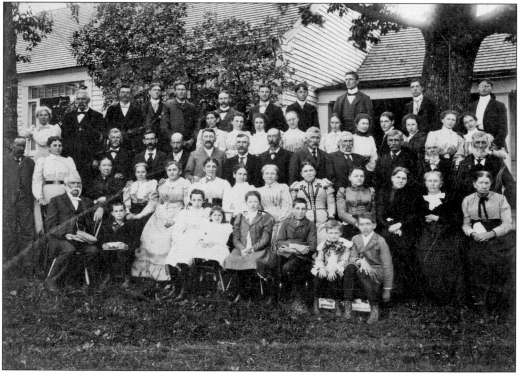

These three children belong to the Dorman family. Nothing is known of this family except the middle names of two of the children are common names in North Berwick. From left to right, they are Dorothea, Charles Cole, and Frances Hayes Dorman. The photograph was taken in 1911. (Courtesy of Melissa Johnson Pierce.)

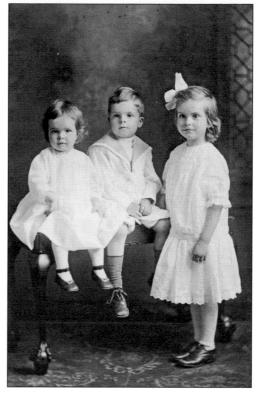

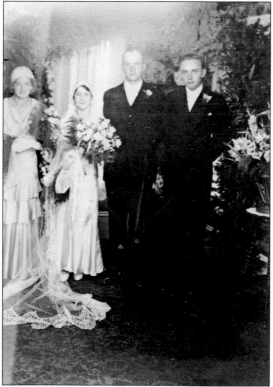

This is a picture of the wedding of Harvey and Elizabeth Hayes Johnson. The matron of honor was Elizabeth "Betty" Mathew, and the best man was Fred Enos Johnson. The wedding took place on September 6, 1932, at noon, in Elizabeth's parents' living room. (Courtesy of Melissa Johnson Pierce.)

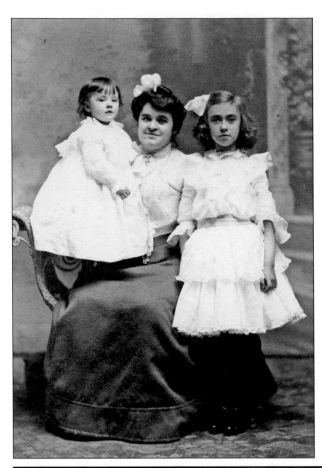

The two girls in this photograph are Amy L. Cormier (one and a half years old) and Beatrice Cormier (nine and a half years old). The woman is unidentified but could be their mother or an aunt. The picture was taken in 1903. (Courtesy of Melissa Johnson Pierce.)

A five-generation family photograph, such as this one of the Fred Staples family, is still important today, as few families are fortunate enough to have this many generations still living to be photographed together.

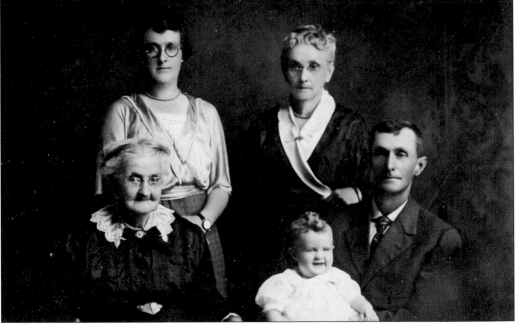

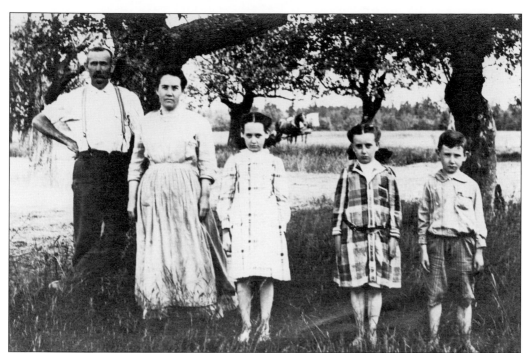

This farm family picture was taken around 1910. Mr. and Mrs. Leland Nutter are standing with their children Alice, Edith, and Alfred Nutter. Note the two horses waiting patiently in the background.

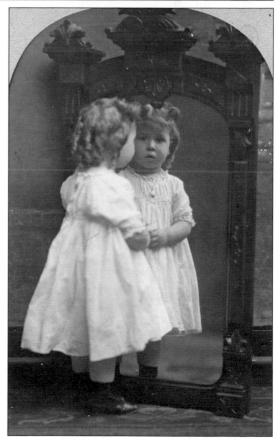

"Who is that other little girl in a mirror?" The invention of the silvered-glass mirror in 1835 led to the mass manufacturing of mirrors and, hence, their greater affordability and availability. (Courtesy of Melissa Johnson Pierce.)

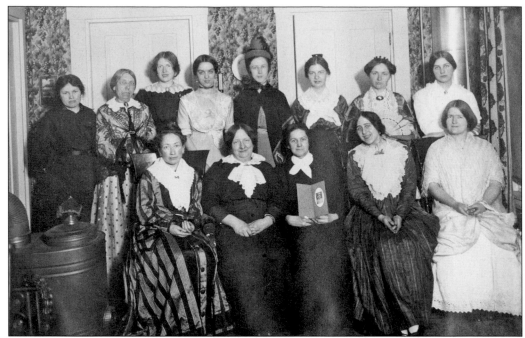

Family and friends are gathered for this photograph at Murle Turner's engagement party. Guests are (seated, from left to right) Grace Russell, Linnie Libby, Florence Dyer, Murle Turner, and Lillian MacDonald; (standing, in no particular order) Ella Greenleaf, Margaret Knight, Ruth Johnson, Clara Knight, Agnes Knight, Elizabeth Hobbs, Miss Walker, and unidentified. (Courtesy of Sherrilyn Lucas.)

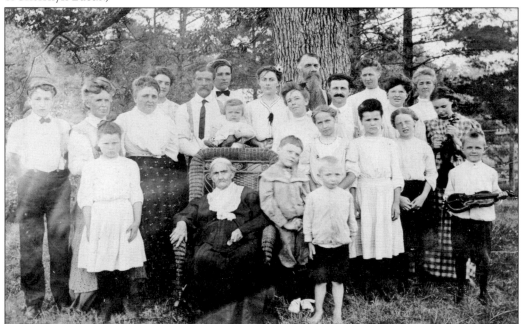

Pictured is a family gathering of five generations of the Randall family in June 1909. Representing the five generations are Lannia Randall (seated) and to her right Harriet Randall Morrell, Mary Morrell Walker, Mabel Carpenter, and baby Forrest Carpenter.

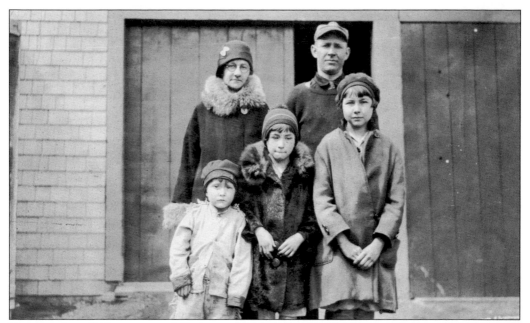

Here is a late-1920s picture of Harley and Mabel (née Neal) Welch with their children Neal, Christine, and Barbara. (Courtesy of Karen Summers.)

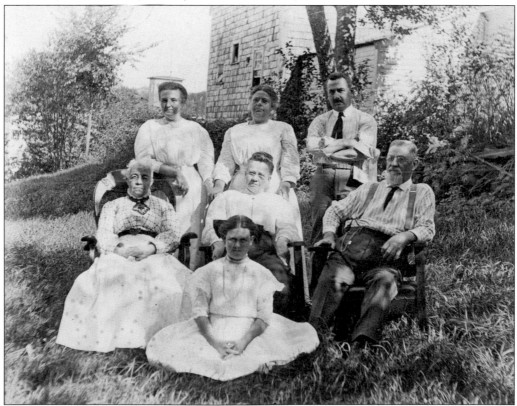

This relaxed unidentified family poses for a c. 1905 photograph in a shady spot in their backyard. (Courtesy of William Wyman.)

This c. 1915 photograph is labeled, "Aunt Lucy, Myra (oldest) and Eleanor." (Courtesy of Melissa Johnson Pierce.)

Pictured are, from left to right, (seated) Gertrude Harden Welch and William E. Welch; (standing) Harley Welch, Helen Welch, and Harry Welch. William raised his family on Portland Street while he worked for the Boston & Maine Railroad for over 30 years. His son Harley also raised his family on Portland Street and worked for the railroad until he became county sheriff. (Courtesy of Karen Summers.)

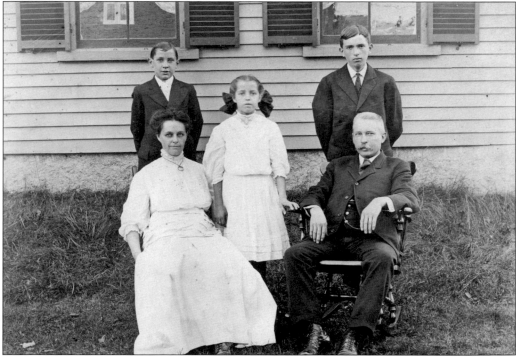

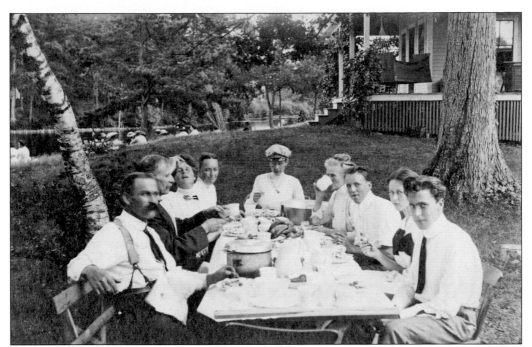

This picnic was enjoyed on the lawn of Frank Austin's camp at Bauneg Beg Pond. On the left side of the table are, front to back, Frank Austin, Frank Knight, Grace ?, and Clara Johnson Knight. Note all the folks having a picnic on the shore of the pond.

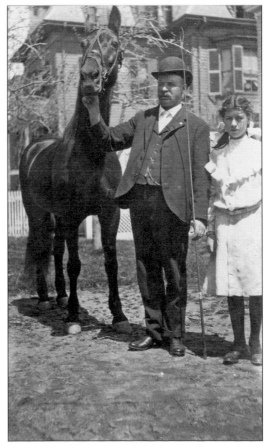

This unidentified man and young girl pose with their family horse. (Courtesy of Melissa Johnson Pierce.)

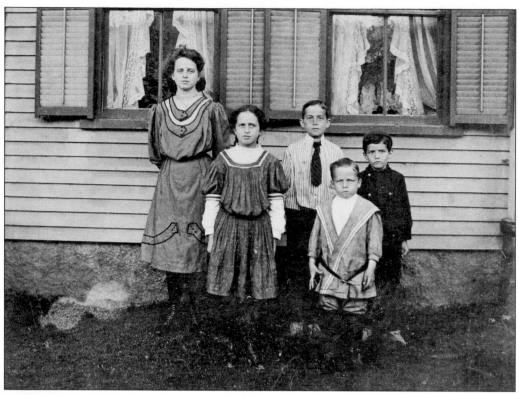

This photograph was taken in 1908 of Marion, Effie, Malcolm, John, and Allen Hayes. (Courtesy of Melissa Johnson Pierce.)

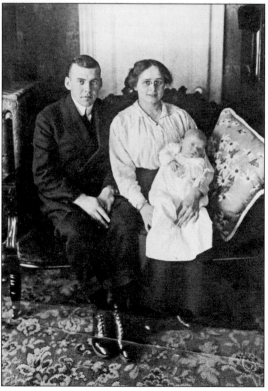

Ned and Marion (née Hayes) Roberts are photographed with their baby Ortelle. (Courtesy of Melissa Johnson Pierce.)

Sisters Nelda Bedell, born March 24, 1897, and Hazel Bedell, born April 4, 1900, are pictured here around 1905. (Courtesy of Melissa Johnson Pierce.)

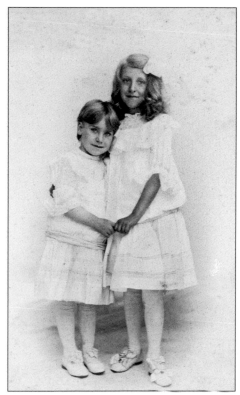

This 1880s picture is of members of the Chadbourne family. Humphrey Chadbourne, forefather of the North Berwick Chadbournes, was baptized in Tamworth, England, in 1615. In Sarah Orne Jewett's book *The Tory Lover*, she refers to him as "the law-giver of Kittery." It was in the next generation that his sons began the lineage of the North Berwick Chadbournes. (Courtesy of Thomas Wellwood.)

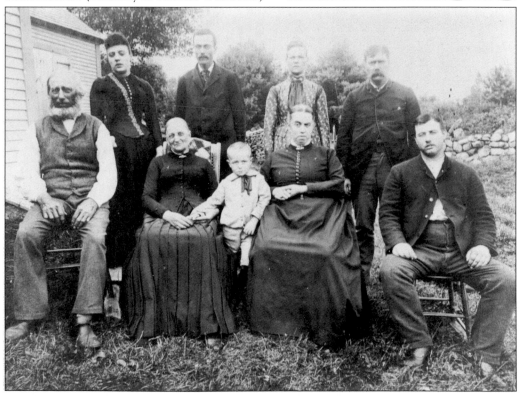

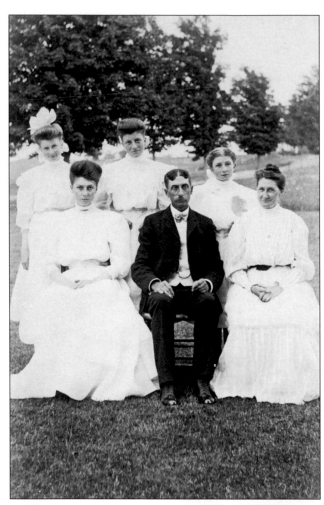

Pictured here in 1905 is Charles Neal's family. Wearing their Sunday best are, from left to right, (first row) Arrianna Neal, Charles Neal, and Marilla Colbeth Neal (wife); (second row) Geneva Neal, Marion Neal, and Mabel Neal. This industrious family worked hard on the farm but spent many happy times singing and playing instruments at home and at Beaver Dam Grange. (Courtesy of Karen Summers.)

Mary Hall, third from the right, celebrates her 68th birthday in July 1909 at her home on Cabbage Hill. (Courtesy of Shelly Kojek.)

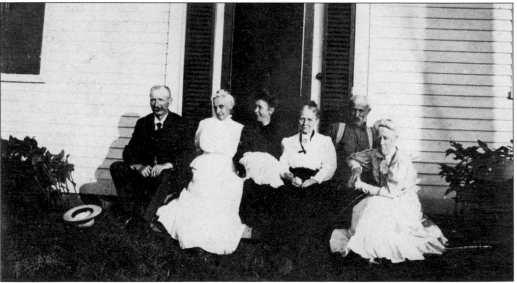

Three

WORSHIP AND
SOCIAL SCENE

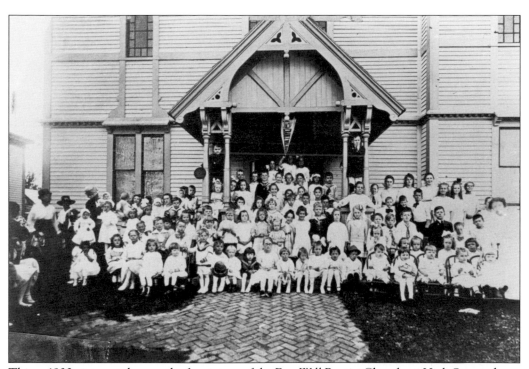

This c. 1900 picture, taken on the front steps of the Free Will Baptist Church on High Street, shows that its Sunday school was well attended. Many young families belonged to the congregation at this time, accounting for the number of children shown here. Numerous pictures of men's groups and ladies' gatherings indicate a very active church over the years. (Courtesy of Andrea Lovell.)

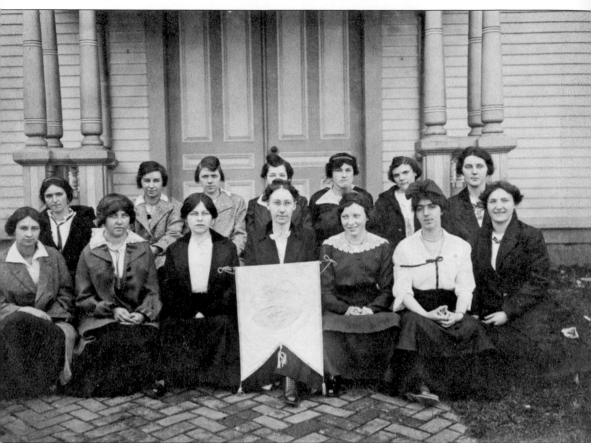

This 1909 photograph shows a women's group at the Free Will Baptist Church on High Street. These women are unidentified, and the No. 09 is all that appears on the banner. The collars on their blouses are much more relaxed than of the previous era when women's clothing had full necklines up to the chin.

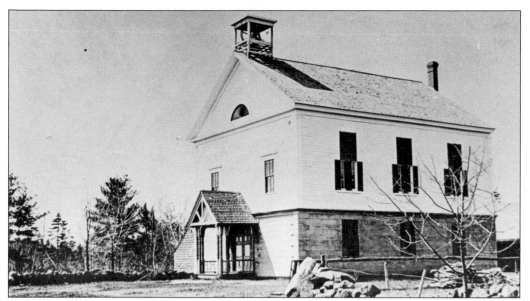

The Beech Ridge Free Will Baptist Church stood on the corner of Beech Ridge Road and Valley Road. It was built in the mid-1800s. The last recorded meeting was September 22, 1907. On May 8, 1967, it was decided to dissolve the church, and this building was torn down a few years later. (Courtesy of William Wyman.)

This group of unidentified men are dressed in their Sunday finest while they pose for the camera. (Courtesy of William Wyman.)

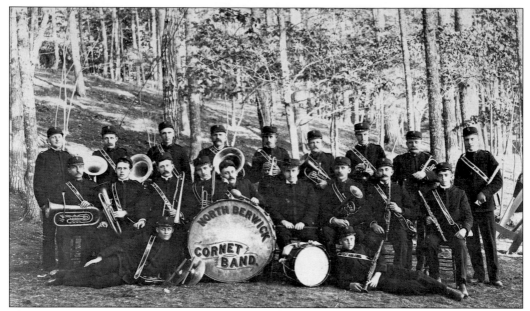

The cornet band was formed in 1879 and included many distinguished-looking gentlemen. Charles Neal is sitting first on the left. Joseph Goodwin Johnson is second from the left standing. The cornet was a very popular instrument until it was overtaken by the revival of the trumpet in the early 20th century. (Courtesy of William Wyman.)

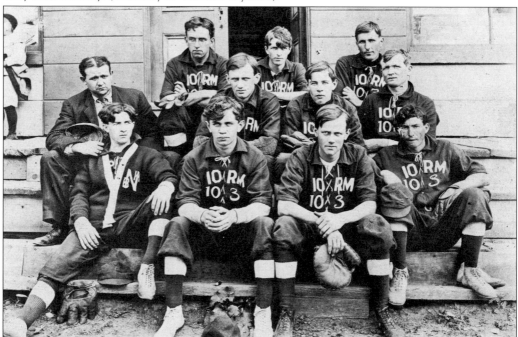

The letters IROM stand for "Improved Order of Red Men," which was a large fraternal organization in North Berwick for many years. The order claims direct descent from the Sons of Liberty, who participated in the Boston Tea Party. In 1834, the name evolved. The group kept customs and terminology of Native Americans as part of their rituals. Here, the group is dressed for a game of ball. (Courtesy of William Wyman.)

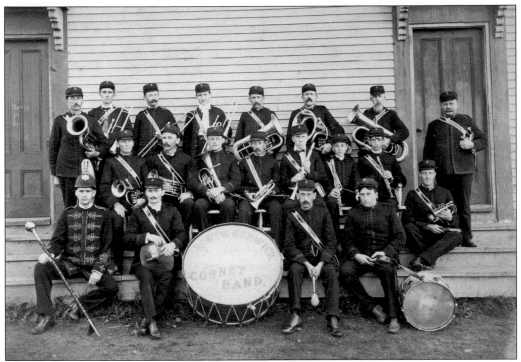

This photograph of the town band was taken in front of the old school that later burned. Note the drum major. (Courtesy of William Wyman.)

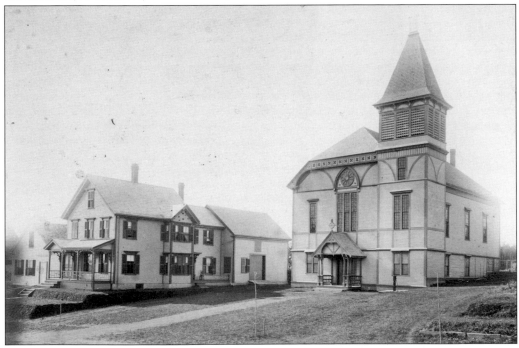

This picture of the Free Will Baptist Church and parsonage on High Street was taken in 1916. In 1920, the congregation voted to join the Congregational Parish of Maine. Thereafter, these buildings were known as a Congregational Church and parsonage.

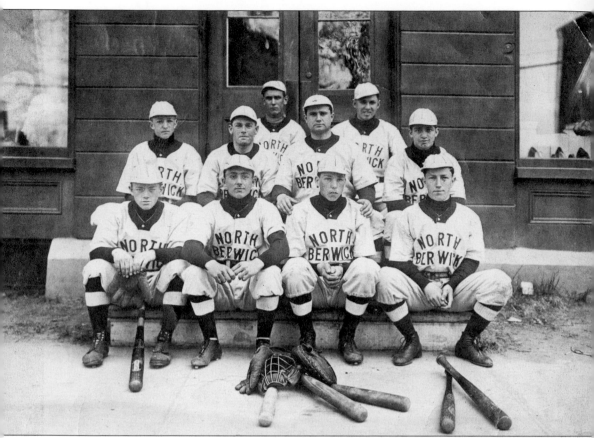

Since the inception of baseball in the mid-19th century, small-town teams have always been popular. It was great entertainment for the whole town and something to look forward to on summer evenings. This c. 1920 picture of a North Berwick town team has the following names on the back, from left to right, (first row) Burton Ford, Albert Nutter, Vernon Johnson, and Carl Swett; (second row) Floyd Johnson, Charles Kezar, Elwood Bessy, and unidentified; (third row) Freeman Johnson and Charles Chadbourne. (Courtesy of Charles "Skip" and Carol Kezar.)

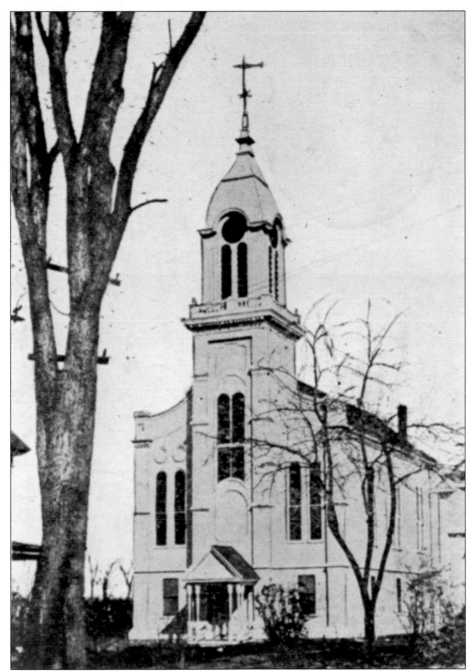

The First Baptist Church in Maine was organized in 1768. The first building was erected on Great Hill near the South Berwick and North Berwick's town line. That building burned, and a new one was constructed and dedicated in 1843. The building in this picture was probably that structure. In 1866, the church was relocated to the center of what was then known as Doughty Falls. It took two years to dismantle the large building and reconstruct it. The great fire of 1906 destroyed this imposing structure. The new building constructed after that fire still stands today in the center of town and is referred to by members as the "Little Brown Church on the Hill." It still holds the distinction of being the oldest Baptist Church in Maine. (Courtesy of Thomas Wellwood.)

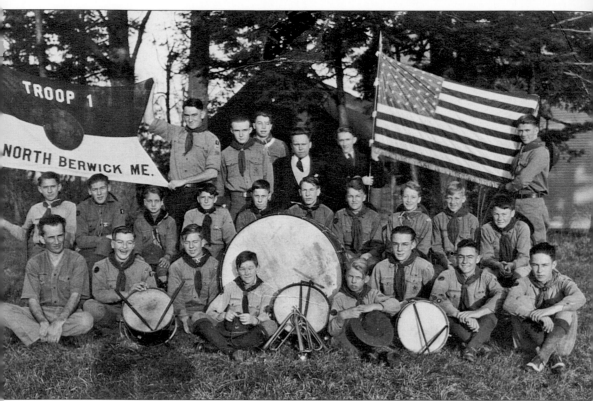

Scouting was first introduced in the United States by Robert Baden-Powell in the year 1910. In the 1920s, North Berwick had its own troop under the leadership of the York County Council, headquartered in Saco. This council merged in 1935 with the Pine Tree Council that was headquartered in Portland. Today, North Berwick's Troop No. 312 is still under the Pine Tree Council. This picture was taken on November 6, 1932, and the flag indicates this was Troop No. 1. Those pictured are, from left to right, (first row) Rev. Harrison Dubbs (scoutmaster), Robert Pickett, Francis Kimball, Elroy Littlefield, David Grant, Granville Wilson, Richard Goodwin, and Kenneth York; (second row) Dexter Abbott, Edwin Strongberg, Kenneth Sayward, Walter Fiel, Lawrence Allen, Deward Miniutti, Robert Allen, Buddy Magee, Winfield Strongberg, and Stanley Tufts; (third row) Francis Neal, Clifford Wilson, Jesse Tufts, Elmer Boyle, Elwood Abbott, and Marshall Abbott. (Courtesy of Edwin Guptill.)

North Berwick actors are costumed up for a school play on stage in the Commercial Block. In the second row on the ends are Orville Johnson and Robert Staples.

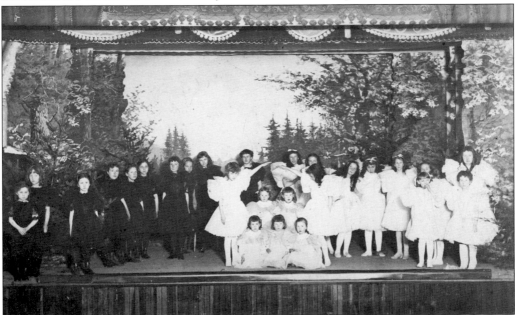

A grammar school play is shown on the stage in the Commercial Block. Clara Knight is third from the left. This stage was very familiar to the town residents as it was used by local actors and also for showing films in the early 1900s.

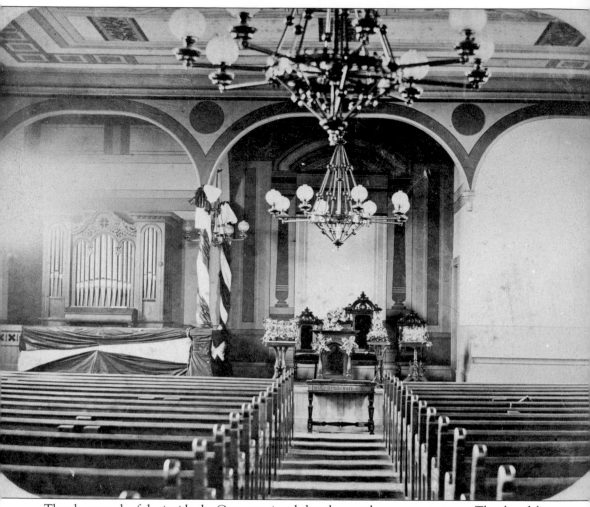

The photograph of the inside the Congregational church was taken many years ago. The chandeliers pictured here were reaffixed in the Oak Woods Church after its 1976 renovation. (Courtesy of Melissa Johnson Pierce.)

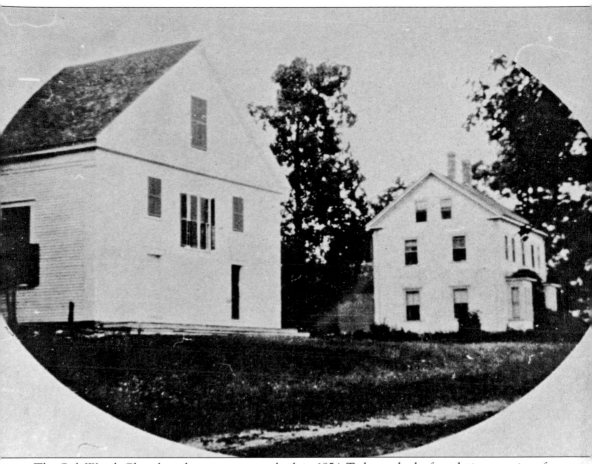

The Oak Woods Church and parsonage were built in 1854. Today, only the foundation remains of the parsonage. Supposedly, it was dismantled and moved to Kennebunk in the early 1900s, when the church closed. There, it is thought, it eventually burned. In 1976, the deteriorated church building was restored and is often used today. It is maintained by the town's historical society.

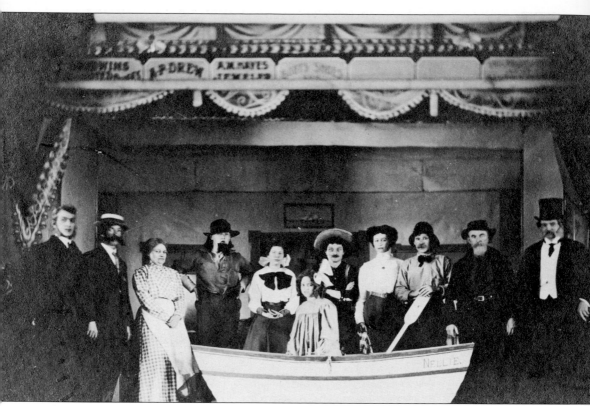

This group of locals are ready to perform a play in the Commercial Block. Since its construction in 1893, the Commercial Block was the center of activity in North Berwick. Upstairs, the hall was used for town meetings, the school gymnasium, a basketball court, a graduation venue, movie theater, and stage for theater productions, such as the one pictured in this photograph. Here, the wonderfully costumed thespians are framed by the stage's ornate and heavy canvas curtain depicting a classical Italian scene. On Saturday nights, silent movies were shown until talkies came in 1928. According to Betty Tufts, the accompanying piano player, Mrs. Dockam, "was a lady of uncertain age and marcelled hair." On the first floor, Hurd's Drugstore was a great meeting place. It was a classic in every way, with a long counter lined with stools to perch on as one waited for delicious ice cream sodas and phosphates. Richard Hurd, a pharmacist, filled prescriptions as well as concocting his own medicinal mixes; among them were Nervine pills for "the nerves" and Smashine pills to fight colds! (Courtesy of Melissa Johnson Pierce.)

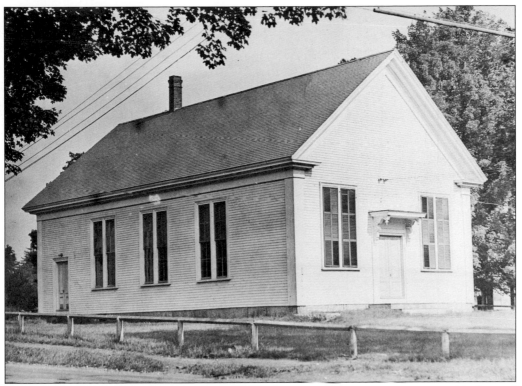

The Friends Meetinghouse was built in 1875. The first meetinghouse was constructed in front of the Friends Burying Ground in 1750. The strong Quaker heritage is seen throughout the town's history and in the many names that are represented in North Berwick cemeteries. This building in the picture still sits today at the corner of Elm and Maple Streets.

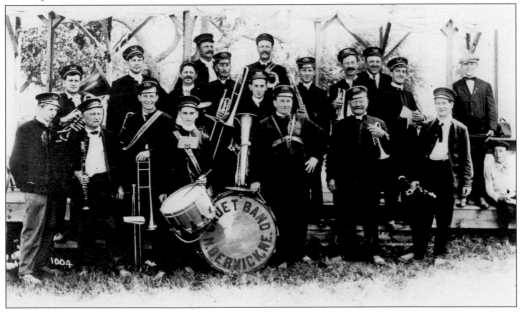

The cadet band in North Berwick is pictured around 1905. Charles Neal is holding the trombone and standing above the drummer.

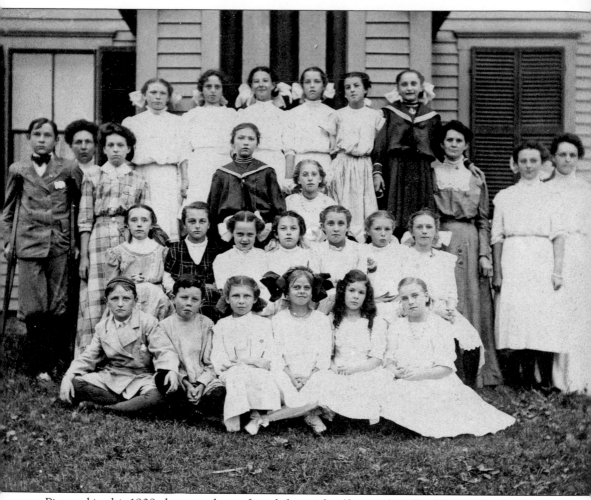

Pictured in this 1908 photograph are, from left to right, (first row) Millard Storer, Gordon Eaton, Flora Moulton, Madeline Dyer, Doris Miliken, and Nelda Bedell; (second row) Agnes Grant, Maude Guptill, Louise Hammond, Pauline Merrifield, Doris Stone, Lena Johnson, and Zueda Robbins; (third row, in no particular order) Harley Welch, Bertha Hutchins, Leslie Potts, Hazel Bedell, Florence Dyer, Grace Hayes, Gertrude Welch, and unidentified; (fourth row) Catherine Kennedy, Effie Hayes, Nelda Naismith, Helen Welch, Virginia O'Connor, and Vivian Storer. (Courtesy of Karen Summers.)

Four

FASHIONS OF THE PAST

These women are probably wearing clothes they made themselves around 1910. The electric sewing machine came into wide use about 1905.

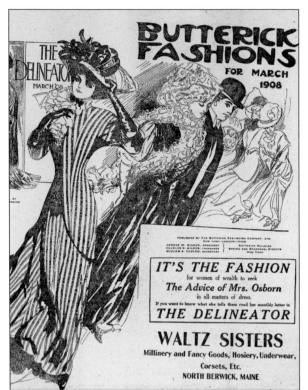

A 1908 pattern book cover from the Waltz sisters' store is shown here. The first sewing patterns were made of tissue paper by the Butterick family. Before then, most women took apart worn out dresses to use as a model for a new one. With the advent of Butterick patterns, not only did dressmaking become much easier, but fashion also became available to men, women, and children of all classes around the world.

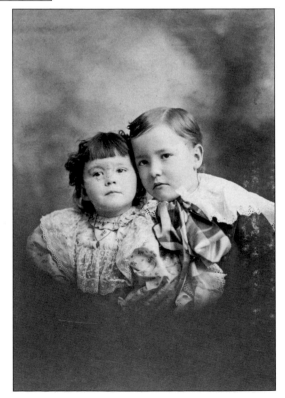

Brother Everett Allen, five years old, and his sister Lulu Francis Allen, two years old, are pictured here in 1896.

In this 1910 picture, an unidentified mother poses with her child. It would be impossible to tell if this child is male or female from the clothing, as all children wore dresses for the first few years.

This c. 1905 photograph was taken in front of Frank Neal's house on Wells Street and has the following written on the back: "Clara Knight on right, Ruth Brook's mother on left." The woman in the middle is unidentified. In the Edwardian era, a woman, whether rich or poor, old or young, would not leave the house without a hat!

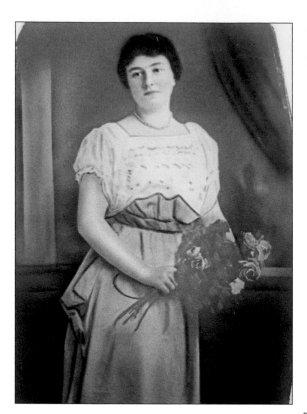

Grace Bedell, pictured here around 1910, later to become Mrs. William Hayes and was a primary school teacher for many years in North Berwick.

This elderly lady poses nicely for this late-19th-century photograph. The whereabouts of this house is unknown, but it is typical of many 18th-century houses in North Berwick. (Courtesy of Sherrilyn Lucas.)

Little Lord Fauntleroy was published in 1886, and the outfit worn by the boy in the book became iconic. Here, Homer Staples is dressed in the popular outfit from the book. Though loved by many mothers, boys generally loathed the costume, especially one as old as the Homer was in this photograph. (Courtesy of Melissa Johnson Pierce.)

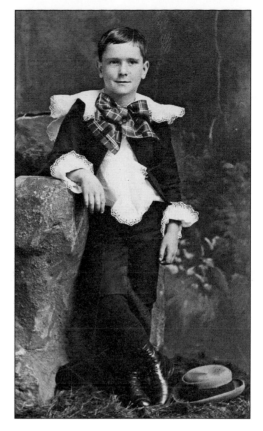

Everett Merryfield is photographed in what was known as a Norfolk suit. It was probably named after the Duke of Norfolk and designed as a shooting coat, as it did not bind when the elbow was raised to aim and fire. It was made fashionable in the 1860s and remained popular in the early 20th century, which was when this picture was taken.

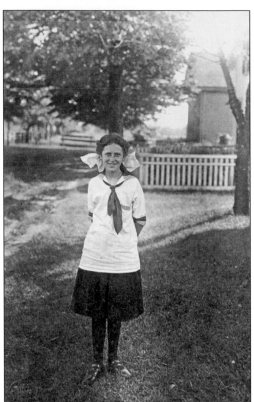

The sailor suit, pictured here, was a popular fashion in the early part of the 1900s. When Coco Chanel used the nautical theme, it immediately became an iconic-style statement, which brought the sailor style into the a la mode of the day.

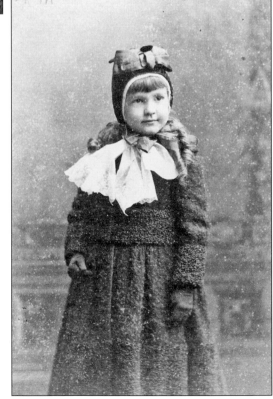

Anna Mary Hill poses in 1895 in a heavy wool jacket and skirt. It is possible that the material was made in the Woolen Mill at North Berwick. She is ready for a Maine winter!

This picture is of Grace Merryfield in the late 19th century. Large collars and short hair cuts were common for both boys and girls in this era.

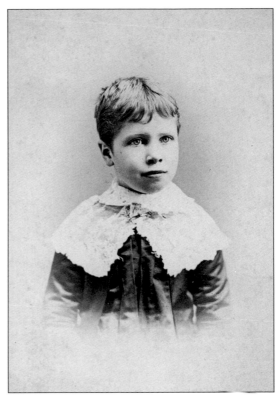

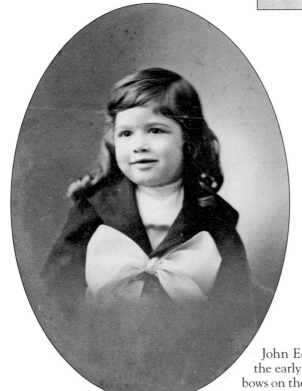

John Edwin Hayes poses for his photograph in the early 20th century. Little boys often wore large bows on their clothes for special occasions. (Courtesy of Melissa Johnson Pierce.)

Anna Mary Hill with her ringlet curls is pictured in 1890.

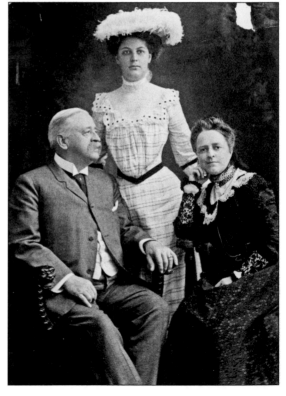

Here a father, mother, and daughter pose at a photographer's studio around 1905. As the silhouette became more slender, the hat became increasingly large. By 1911, hats were at their largest, often with the brim extending beyond the wearer's shoulders.

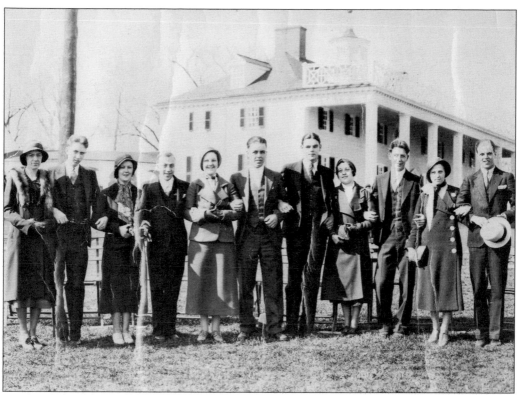

This North Berwick senior class had its picture taken at Mount Vernon on its 1932 Washington, DC, trip. Seniors are, from left to right, Ann Hussey, Richard Dustin, Ruth Drake, Robert Stone, Clara Foster, Elroy Day, Curtis Goodwin, Mary Thibeau, Arthur Johnson, Mae Kennedy, and Kendric Mathews.

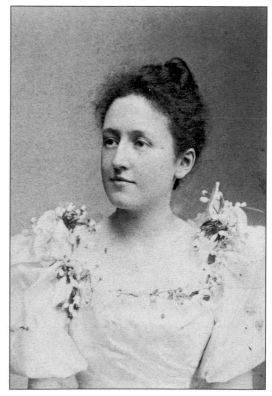

A pretty young woman poses in her beautiful dress for a special occasion around 1900. (Courtesy of Melissa Johnson Pierce.)

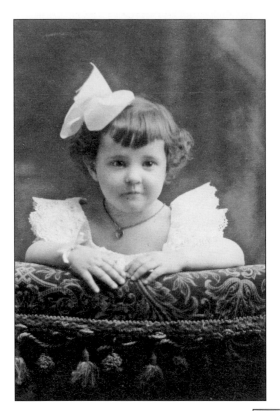

Amy Louise Cormier, who was born in 1901, has her photograph taken in 1904. Her parents were Gordon and Grace Cormier. (Courtesy of Melissa Johnson Pierce.)

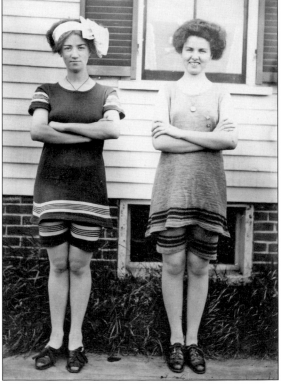

Two young women show off their then modern bathing suits around 1920. These were a change from the often black, knee-length, and puffed sleeves woolen dresses worn over bloomers and long black stockings and paired with lace-up slippers and bathing hats, which were the fashion just a few years earlier! (Courtesy of William Wyman.)

Written on the back of this photograph is "Laughing Loon Camp." Research found a Laughing Loon Camp on Little Ossippee Lake in Waterboro, Maine. This North Berwick boy's picture was taken around 1910. (Courtesy of Melissa Johnson Pierce.)

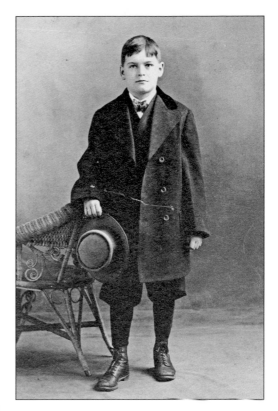

This photograph of Effie Johnson was taken around 1910. She is dressed in a fashionable tiered gown of this era. (Courtesy of Melissa Johnson Pierce.)

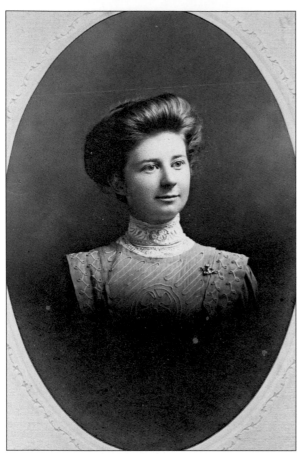

Geneva Neal Hobbs was born in 1890. This photograph was taken when she was 20 years old. Her hair and dress are in the Gibson Girl fashion of the early 1900s. (Courtesy of Karen Summers.)

The women in this c. 1912 photograph are dressed in their warm winter coats, hats, and muffs.

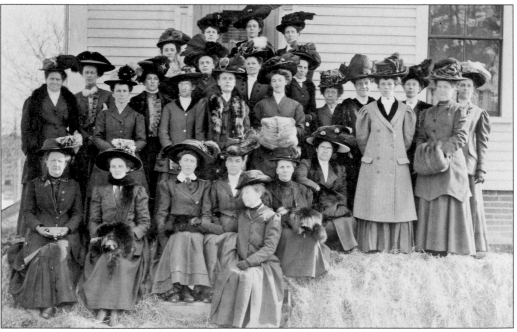

This is an old tintype, taken about 1880, of Harriet Randall Morrell. She is dressed in a gorgeous Victorian-era gown. (Courtesy of Thomas Wellwood.)

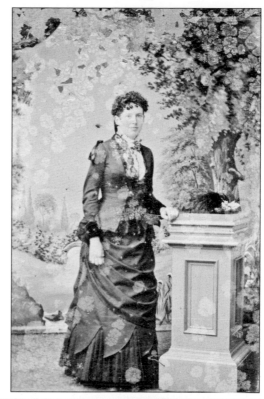

This postcard of Dana (left) and Melvena (right) Tobey is dated 1908 and addressed to Lucy A. Hill, York Beach, Maine. (Courtesy of Thomas Wellwood.)

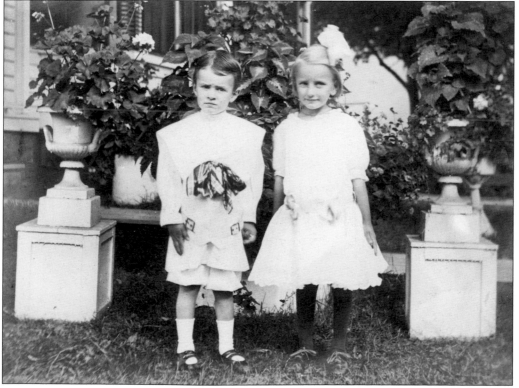

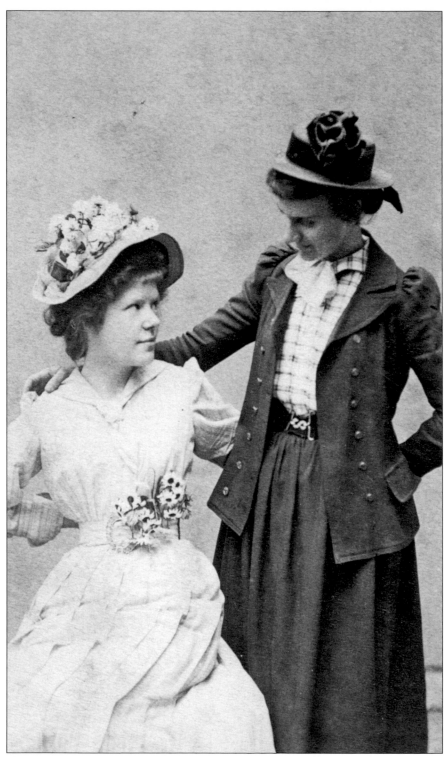

The Waltz sisters, seen in this photograph around 1900, ran a millinery and fancy goods store in North Berwick at the turn of the 20th century. There store was next to the Goodwin Block.

Five

LEISURE TIME

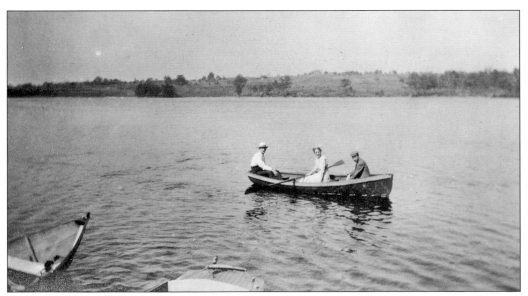

The three people in this picture are enjoying a leisurely day on Bauneg Beg Pond in the early 1900s. This pond is located within the larger Great Works River watershed, covering 179 acres between North Berwick and Sanford. For many years, it has afforded the local community with recreational opportunities, such as swimming, boating, and fishing as well providing valuable habitat for wildlife. (Courtesy of Sherrilyn Lucas.)

These two young men in the photograph are going hunting. On the left is Francis "Tweet" Hal;, and on the right is Wayne Wormwood. Each man is likely wearing a Woolrich shirt. Hunters having to wear blaze orange did not become a law in Maine until 1967, and the blaze cap and vest were mandated in 1973. (Courtesy of Sherrilyn Lucas.)

Edith Littlefield is seen here fishing on Bauneg Beg Pond 1932. Bauneg Beg Pond supports a warm-water fishery, which includes species of brown bullhead, chain pickerel, common shiner, largemouth and smallmouth bass, pumpkinseed, white and yellow perch, and white sucker. (Courtesy of Barbara Fitzmaurice.)

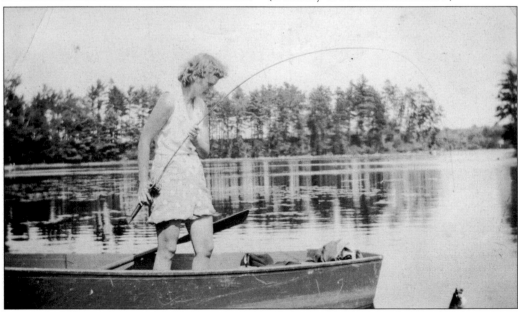

From this picture of Edith Littlefield, it looks like fried fish is on the menu for the evening meal! (Courtesy of Barbara Fitzmaurice.)

Romayne Belmore is going to take a ride on her new bicycle. With silver fenders, chain guards, headlights, horns, and balloon tires, the designers clearly attempted to make bicycles look as much like motorcycles as possible. The popular roadsters of the day were, in fact, dubbed moto-bikes. If ever a bike needed a motor, this was it, as it could weigh as much as 65 pounds! (Courtesy of Sherrilyn Lucas.)

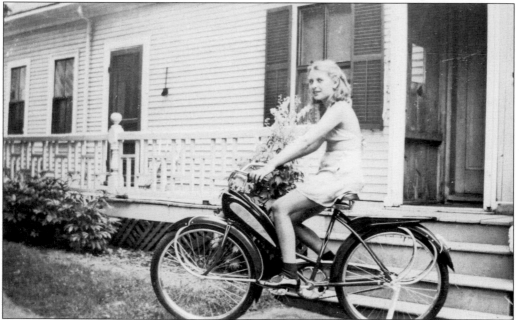

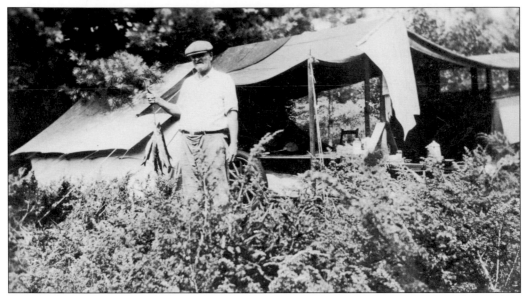

Alvah Littlefield shows off his Bauneg Beg catch in this picture. In 1932, camping was really "roughin' it" with lots of tarps and poles to provide shelter. There were no pop-up tents or campgrounds in this era, so spots like this were chosen randomly around the pond.

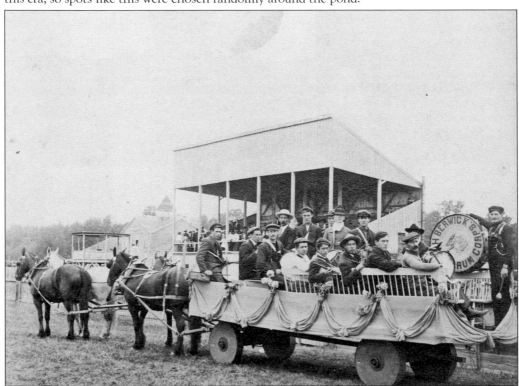

Pictured here is the North Berwick Drum Corps at the Pine Grove Fairgrounds. The fairgrounds were located about a mile out of town on Route 4. An agricultural association was founded in the late 1800s by townspeople, and an annual fair was held here for many years. (Courtesy of William Wyman.)

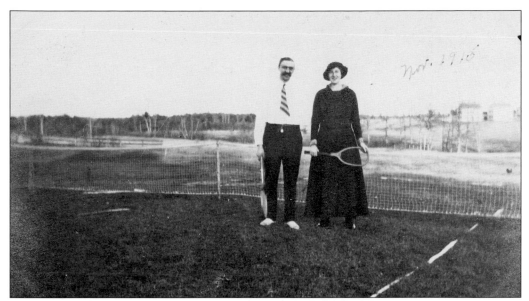

Margaret Knight (Belmore) and possibly her brother are photographed at the lawn tennis court on High Street in November 1915. They are dressed in their day clothes to play. At least, the dress code had changed dramatically for women who, at the end of the 19th century, wore full bustles, dress hats, and gloves on the court! In the background, houses on Prospect Street can be seen. (Courtesy of Sherrilyn Lucas.)

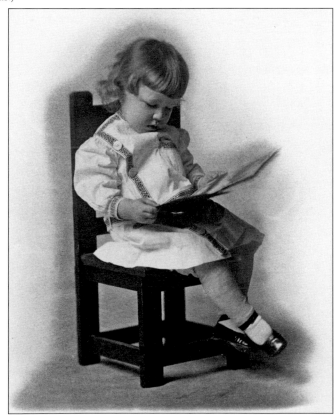

Charles Edwin Gould, age two in 1911, is enjoying a picture book. Perhaps it was Beatrix Potter's *The Tale of Timmy Tiptoes* or *The Wind in the Willows* or *The Secret Garden*.

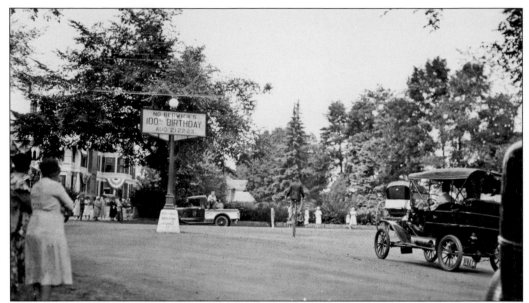

The centennial festivities in 1931 included a parade of floats followed by a basket picnic under a large tent in Mary Hurd's field. Band music played for the occasion. On Friday, there was a concert with formal presentations, and Saturday was devoted to sporting games and an evening barn dance. The celebration closed Sunday morning after a chorus performance and an address by Dr. Rufus M. Jones. (Courtesy of June Guptill.)

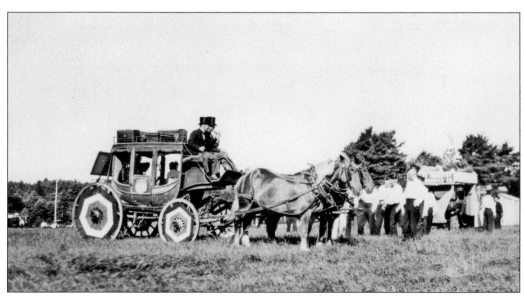

This stagecoach is festively decorated for the 100th anniversary parade. The women riding inside are wearing bonnets, and the men driving are wearing formal attire and top hats. (Courtesy of Thomas Wellwood.)

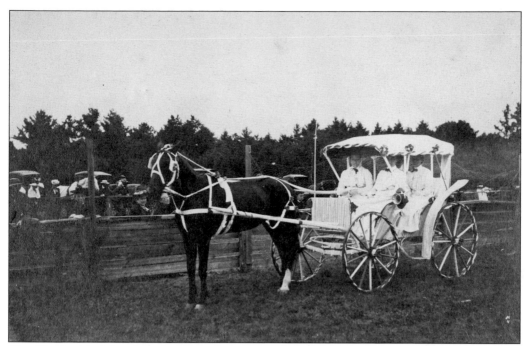

The Charles Neal family is shown in this picture at the Rochester Fair around 1910. (Courtesy of Karen Summers.)

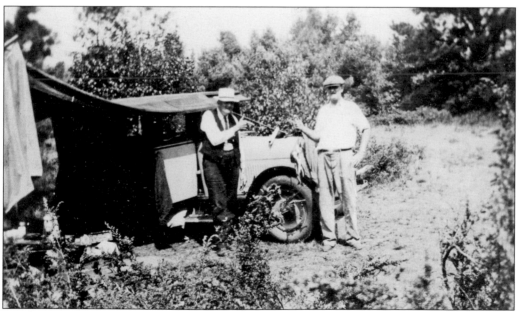

Alvah Littlefield (on the right) and his friend Eddie are seen camping at Bauneg Beg Pond. It looks like there will be fish for supper! (Courtesy of Barbara Fitzmaurice.)

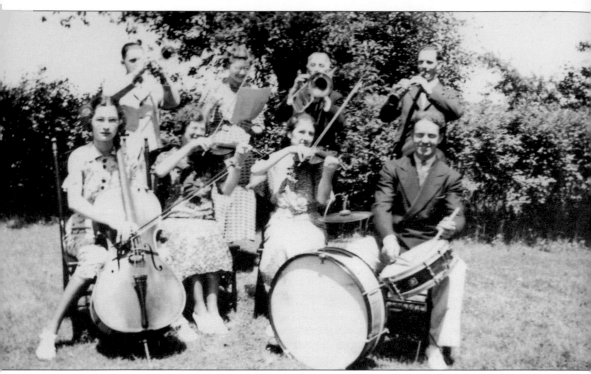

Pictured here in 1936 are three generations of the musical Neal family who performed together. Pictured are, from left to right, (first row) Christine Welch, Geneva Neal Hobbs, Mabel Neal, and Ronald Neal; (second row) Vinton Neal, Barbara Welch, Charles Neal, and Lloyd Neal. Music was an integral part of the "singing Neals" and went as far back as Reuban Neal (1786–1857), who ran a music school, built an organ, and taught fife and drum. (Courtesy of Karen Summers.)

Six

SCHOOL DAYS

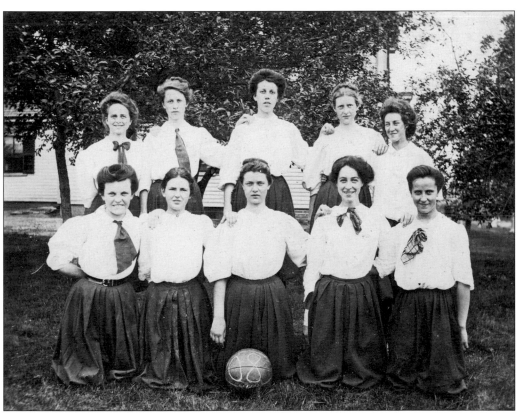

Pictured here is the 1908 North Berwick girls' basketball team. That year, the Women's Basketball Rules Committee suggested, "Coaches emphasize the feminine traits of their players on and off the court." The first women's basketball game was held at Smith College in 1893. All doors were locked, and no men were allowed! In 1897, the first high school game in the State of Maine was played at Thornton Academy in Saco. (Courtesy of Sherrilyn Lucas.)

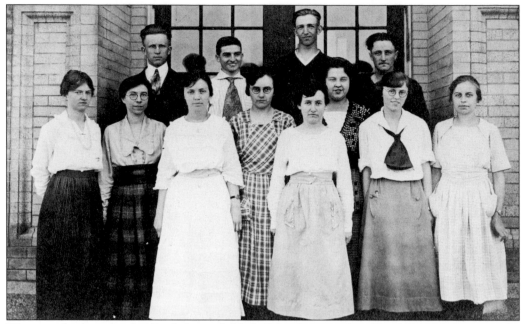

This is a photograph of a North Berwick High School senior class. Floyd "Jack" Johnson is the tall student in the second row.

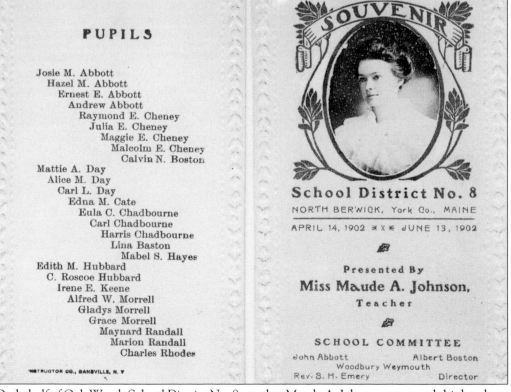

PUPILS

Josie M. Abbott
Hazel M. Abbott
Ernest E. Abbott
Andrew Abbott
Raymond E. Cheney
Julia E. Cheney
Maggie E. Cheney
Malcolm E. Cheney
Calvin N. Boston
Mattie A. Day
Alice M. Day
Carl L. Day
Edna M. Cate
Eula C. Chadbourne
Carl Chadbourne
Harris Chadbourne
Lina Baston
Mabel S. Hayes
Edith M. Hubbard
C. Roscoe Hubbard
Irene E. Keene
Alfred W. Morrell
Gladys Morrell
Grace Morrell
Maynard Randall
Marion Randall
Charles Rhodes

INSTRUCTOR CO., BANSVILLE, N. Y

SOUVENIR

School District No. 8
NORTH BERWICK, York Co., MAINE
APRIL 14, 1902 ✕ JUNE 13, 1902

Presented By
Miss Maude A. Johnson,
Teacher

SCHOOL COMMITTEE
John Abbott Albert Boston
Woodbury Weymouth
Rev. S. H. Emery Director

On behalf of Oak Woods School District No. 8, teacher Maude A. Johnson presented this brochure to her students, the class of 1902.

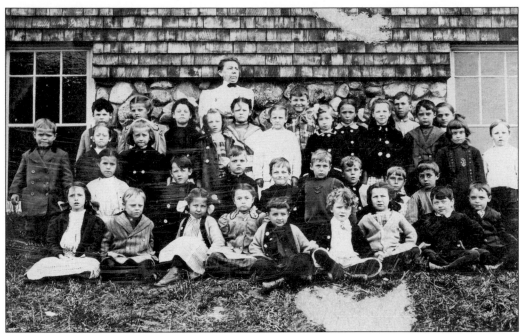

An early-1900s elementary school class in downtown North Berwick poses beside the First Baptist Church.

Photographed is an eighth-grade graduation class with its teacher. Helen Welch is second from the right in the first row. In order to graduate from the eighth grade, students had to take a state test given at the village school. (Courtesy of Karen Summers.)

The 1931 North Berwick High School seniors pose at Mount Vernon on their Washington, DC, class trip. (Courtesy of Alice Dutch Foss.)

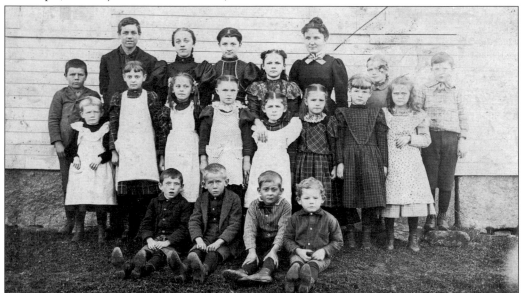

The names on this picture indicate these students attended the Oak Woods one-room school around 1900. From left to right are (first row) Roscoe Hubbard, Ernest Abbott, Carl Chadbourne, and Lidney Miller; (second row) Alfred Morrell, Mabel Hayes, Edith Hubbard, Bea Staples, Alice Day, Gladys Morrell, Eula Chadbourne, Irene Keene, and Hazel Abbott; (third row) Granville Littlefield, Molly Getchel, Annie Abbott, Ruth Keene, Louise Baston (teacher), Josie Abbott, and unidentified.

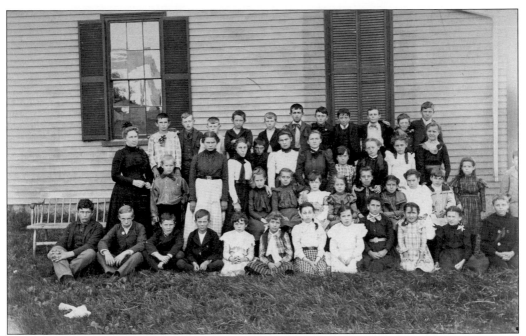

These schoolchildren and their teacher are having their picture taken next to the village school.

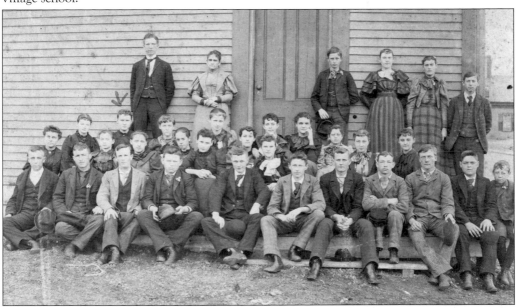

These 1894 students are, from left to right, (first row, with one extra name per the back of the photograph) Charles Boyle, Leslie Sherbourne, Orele Johnson, David Austin, Edward Keeting, Carl McCorrison, Ezra Littlefield, Bert Homes, Roy Staples, Carl Tucker, Homer Tobey, and ? Belmore; (second row) Ida Murray, Grace Furlong, Angie Adams, Edith Buffum, Bertha Nutter, Ida McCrellis, Carrie Sargent, Nellie Colbath, and Celia Goodwin; (third row) unidentified, Maud Johnson, Eva Boston, Alice Goodwin, Grace Knight, Evie Davies, Josie Greenleaf, and Daisy Nash; (fourth row) assistant Horatio Butler, teacher Ms. Maxwell, Allen Hayes, Annie McCorrison, Ethel Knight, and Fred Hubbard.

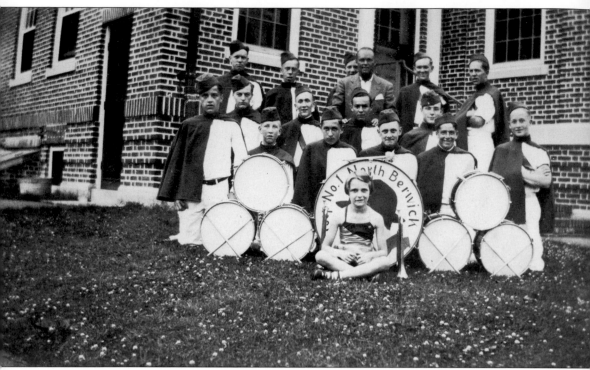

Most schools did not have formal music programs until the early 1900s. Bands were an important part of any town's entertainment, and community bands gave those interested in learning to play an opportunity to be taught by these musicians. As school bands developed, funds needed for instruments, uniforms, and sometimes for a bandleader were paid for by local donations from individuals as well as businesses. Because of the instruments pictured here, it appears that this is a drum and bugle corps. At the front are two field trumpets, which are straight valveless bugles in the key of G. The drums would be single tension. Classic drum and bugle corps served as signaling units during the Civil War. With the invention of the radio, bugle-signaling units became obsolete, and their equipment was sold to VFWs and the American Legion. No doubt the Legion or the VFW supported this group of students. Romayne Belmore is sitting in front of the brass drum. (Courtesy of Sherrilyn Lucas.)

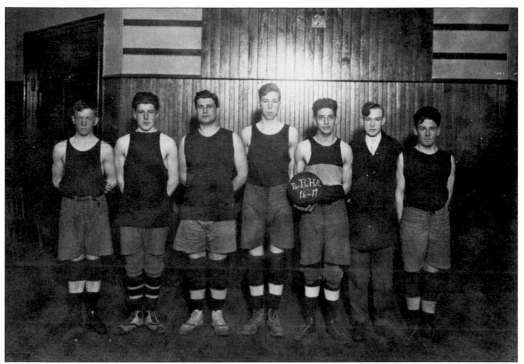

North Berwick's High School basketball team is seen here in 1917. (Courtesy of Melissa Johnson Pierce.)

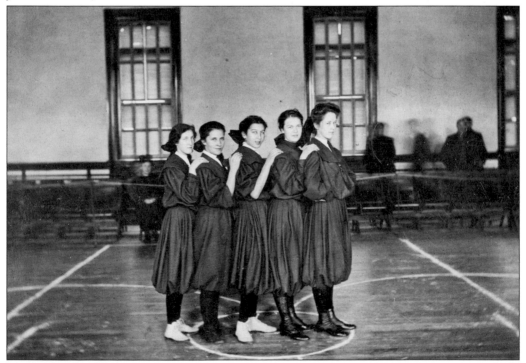

The high school girls' basketball team poses for this picture upstairs in the Commercial Block. All indoor school activities were performed in this building.

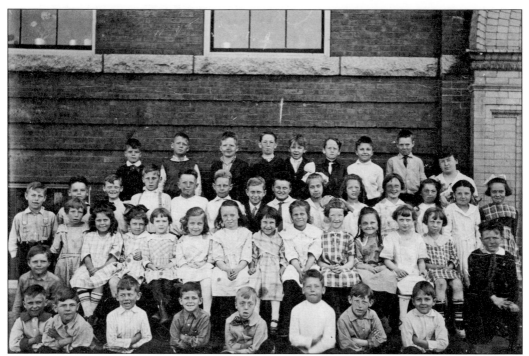

This picture shows village school children from grades two and three with their teacher Alice Brown.

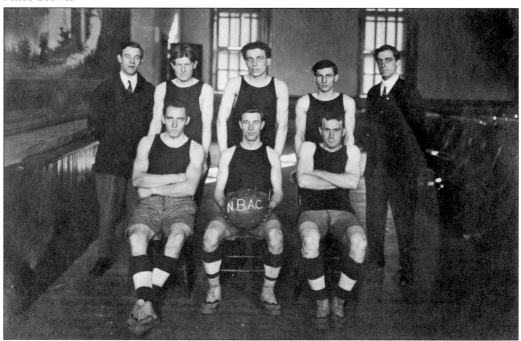

The North Berwick Athletic Club is photographed upstairs in the Commercial Block in the early 1900s. "Len" Bracy, seated in the first row on the right, managed the Hurd Estate and chauffeured Mary Hurd. When Mary died, she willed Len the Hobbs Inn, which sat across from the Hurd Manor. The corner on which it sits came to be known as Bracy's corner.

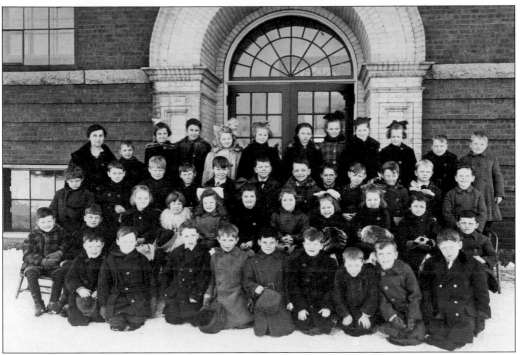

These schoolchildren and their teacher are bundled up for winter as they have their picture taken in front of the brick school. (Courtesy of Melissa Johnson Pierce.)

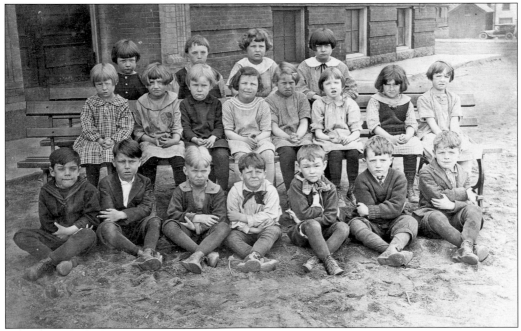

These young schoolchildren look unhappy as they pose for their picture. Note the large bows on the boys in the front row. (Courtesy of Melissa Johnson Pierce.)

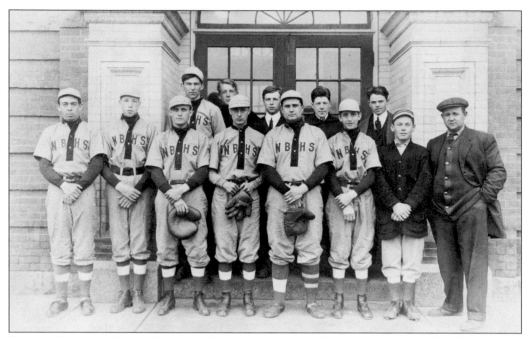

Pictured here is a North Berwick High School baseball team with its coach. (Courtesy of William Wyman.)

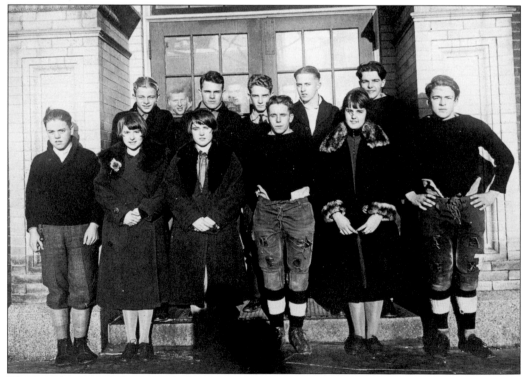

The North Berwick boys' football team and girls' cheerleading squad pose for this picture. By the late 1800s, girls were allowed to join the all-male cheerleading squads. (Courtesy of Melissa Johnson Pierce.)

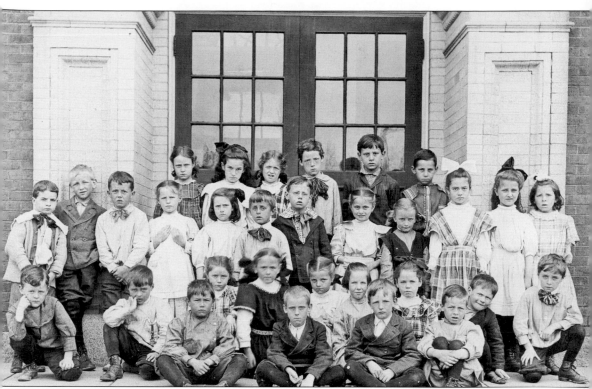

The children in this photograph look very serious. In early photography, long exposure time of one to two minutes was needed to complete the process. Subjects were told to sit still for that period of time, as any movement would cause the photograph to blur. Smiling for that long without moving was an impossible feat, so they just sat still and waited.

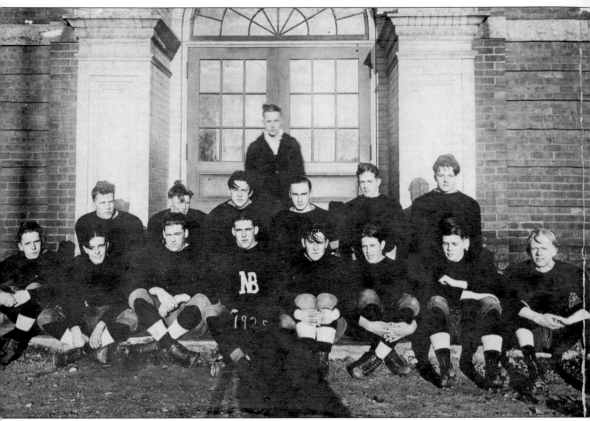

The 1925 varsity football team members were, from left to right, (first row) Roger Annis, Maurice Pickett, Gerald Baston, Lawrence Baston, Guy Lowe, Carl McCrellis, Roger Brown, and William Dyer; (second row) Javis Shibles, Walter Sunstrom, Carl Hatch, Wayne Roberts, Kenneth Birch, and Max Pickett. The person standing in the back is unidentified.

Seven

ON THE FARM

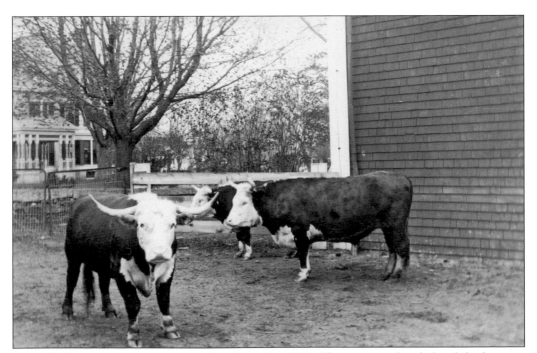

Mary Hurd's steers are photographed in November 1931. They are standing behind the barn on the Hill property. In the background, the portico on the side of Hurd Manor can be seen.

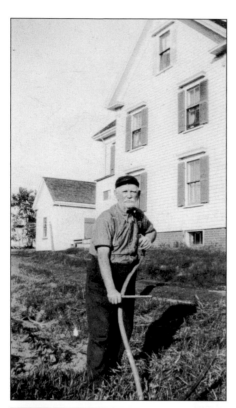

David Nutter is pictured here with his hand scythe. Mowing with a scythe was still fairly common in this era, even after the advent of mowers (whether horse or tractor drawn), as they were ideal tools to open up a meadow.

Frank Neal is photographed here with his milk delivery wagon with which he delivered milk all over North Berwick. Tragically, he was struck by a car while making a delivery on May 29, 1930. He died one day later at the Sanford Hospital. He was only in his early 50s.

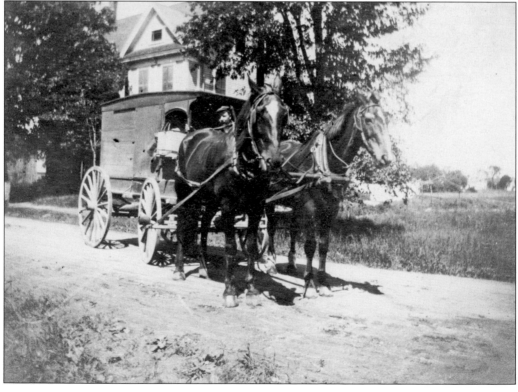

This is a picture of the Frank Neal farm on Wells Street. According to an article in the *Dover Democrat*, the family moved to this farm in 1907. (Courtesy of Karen Summers.)

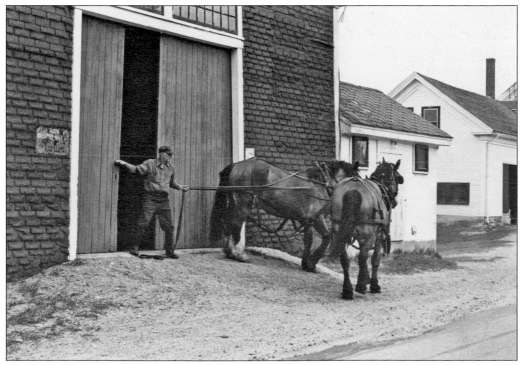

Frank Neal's son Roger Neal and his team of horses farmed into the late 1900s. Roger, pictured here, woke at 5:00 a.m. and often worked until 2:00 a.m.—seven days a week! At one time, Roger had 40 cows to milk and 90 acres of hay to farm. As he got along in years, he continued to "stick to his old ways because he felt safer with horses hauling hay into the barn as they did not backfire and release a spark that could start a fire." (Courtesy of the *Dover Democrat*.)

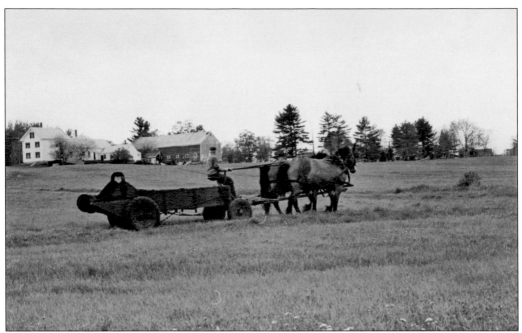

Roger Neal spreads manure on the field behind his farm in this picture. He was doing his bit for energy conservation back then. He told a reporter, "I'd be using 'round five gallons of gas if I was using my tractor, but all I've got to give these horses is a bale of hay." (Courtesy of the *Sanford Daily News*, July 12, 1978.)

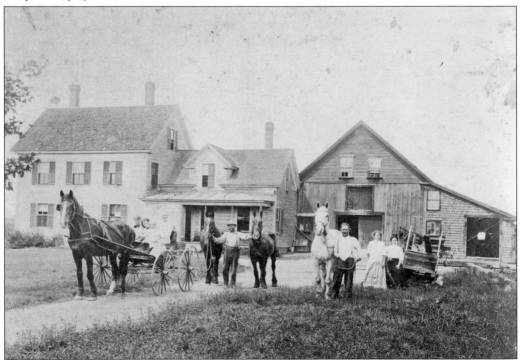

This farmhouse and family have not been identified. The photograph was found in the Brackett Hall collection. (Courtesy of Shelly Kojek.)

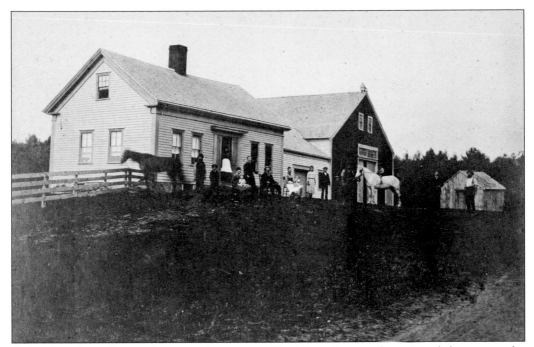

A family with its farm is shown in this picture. Traveling photographers visited the area at the turn of the century. Farmers and their families would dress in their finest and put their animals and machinery on display to record their lives for posterity. (Courtesy of William Wyman.)

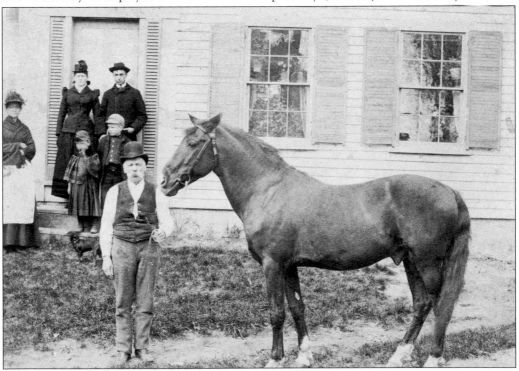

Hiram Edwin Hayes and his wife, Jennie Blanche (née Staples) Hayes, pose in the doorway for this picture. The others are unidentified. (Courtesy of Melissa Johnson Pierce.)

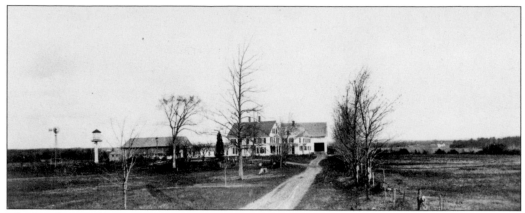

The Brackett Hall farm is pictured here on what was to become known as Cabbage Hill due to acres of cabbages raised in his fields. (Courtesy of Shelly Kojek.)

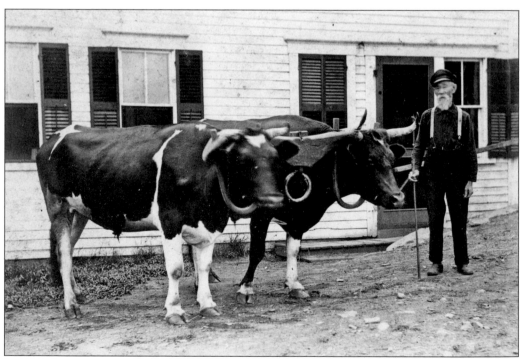

In 1909, this team is pictured with a farmhand on the Brackett Hall farm. These rugged creatures were the lifeline of a farm before the invention of the tractor at the turn of the 20th century. (Courtesy of Shelly Kojek.)

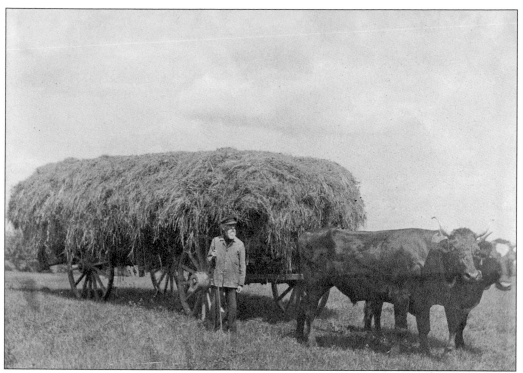

This wagon is loaded with freshly cut hay on the Brackett Hall farm. Haying was hard work on the farm. The loose hay had to be loaded correctly or it would end up back on the ground. (Courtesy of Shelly Kojek.)

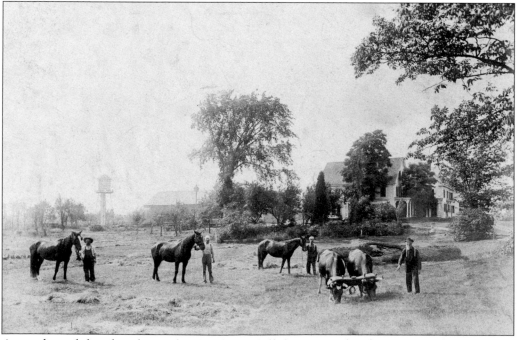

Animals and farmhands on the Brackett Hall farm pose for this picture. (Courtesy of Shelly Kokjek.)

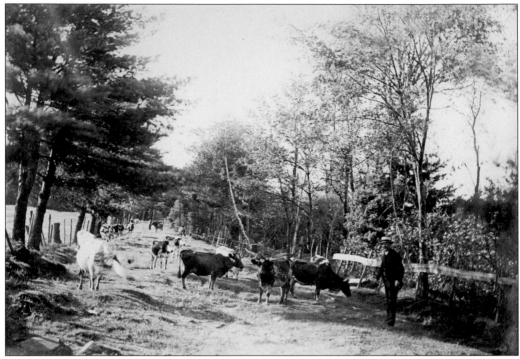

This gentleman is pictured with the cows in the lane at Brackett Hall farm. (Courtesy of Shelly Kojek.)

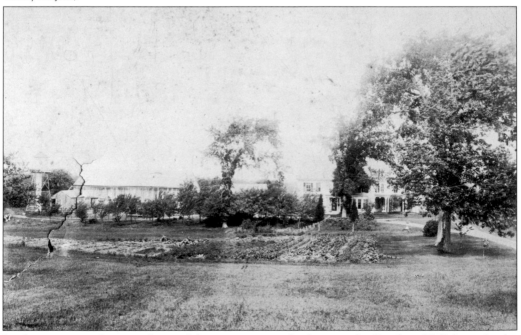

In this picture, a large garden and fruit trees grace the lawn at the Brackett Hall farm. In the background can be seen a large barn and a water tower. Large farms had water towers before plumbing was available to keep a supply of water from the well for the animals and gardens. (Courtesy of Shelly Kojek.)

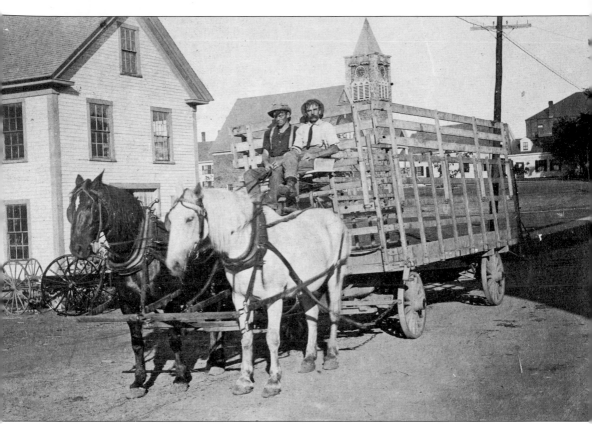

Shown here is one of many horse-drawn wagons used around town in 1906. Hosea Perkins is the driver, and Edgar Allen sits beside him. These wagons were used to haul various goods to and from farms and businesses. It is possible these two men are just coming back from unloading a wagon of barrels at the railroad station. Another picture of a full wagon can be seen on page 125. (Courtesy of William Wyman.)

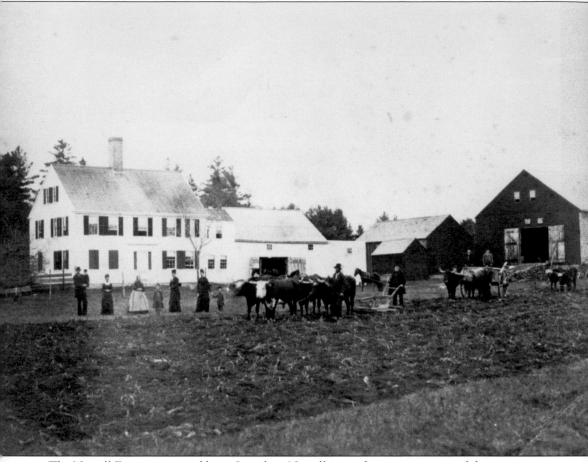

The Nowell Farm is pictured here. Jonathan Nowell was a fervent supporter of the patriot cause against the king of England and, according to the Daughters of the American Revolution, served in the Battle of Bunker Hill and was a major in Gen. George Washington's corps of officers. He and Elizabeth Frost had two children, Ebenezer (1768) and Mary, who died in infancy (1794). Ebenezer married Rachel Grant in 1792. It was Ebenezer who built the farm in this photograph. The deed for the farm, transferring the land and buildings from Ebenezer to his son Joshua, is dated 1841. It reads, "Homestead farm situated in said North Berwick containing one hundred acres, more or less with the buildings thereon. Bounded by land lately owned by William Frost, lands of John Abbott, George Frost, Moses Frost and Joshua Nowell, including the tract of wooded land containing about eighteen acres which I purchased from Dominicas Goodwin." All members of the family are buried in a cemetery on the property. (Courtesy of Stephen and Alice Purington.)

Eight

GETTING ABOUT

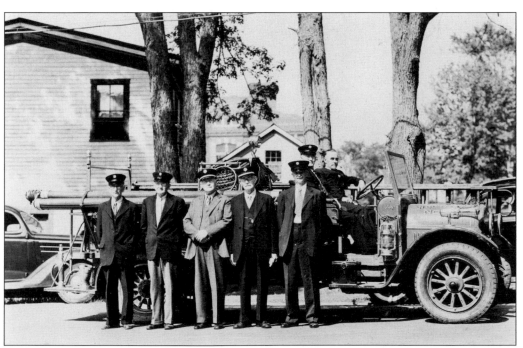

Town dignitaries, wearing fireman hats, are seen posing in front of a new fire engine, possibly purchased around 1925. According to the town records, the first motorized fire truck was bought in 1925.

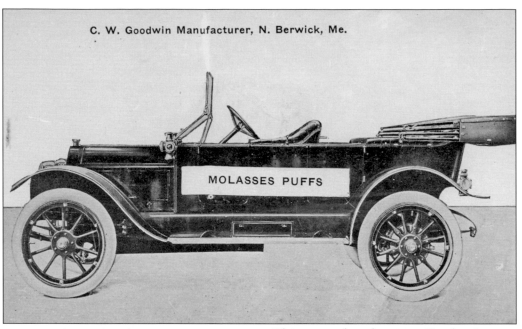

C. W. Goodwin Manufacturer, N. Berwick, Me.

MOLASSES PUFFS

This postcard is advertising Goodwin's Famous Molasses Puffs. C.W. Goodwin owned the block near the railroad tracks, in which he had a variety store and lunch counter.

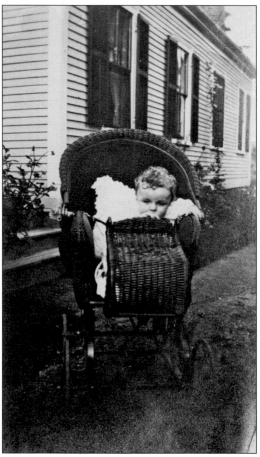

Sherrilyn Lucas is seen here peeking above her stroller. Sherrilyn is the daughter of Romayne Belmore and the granddaughter of Jim and Margaret Belmore. (Courtesy of Sherrilyn Lucas.)

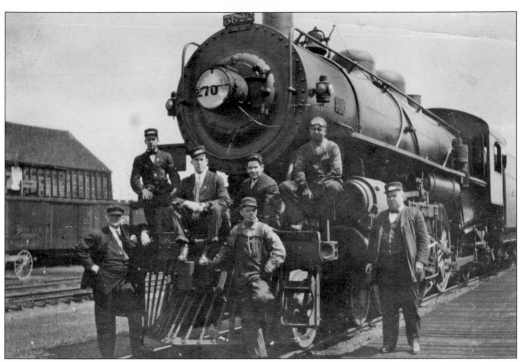

This picture of Engine No. 270 at the North Berwick Depot shows Herbert Staples sitting in the middle of the cowcatcher on front of the locomotive. (Courtesy of Melissa Johnson Pierce.)

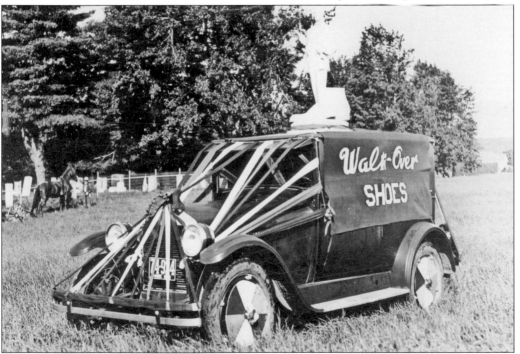

This decorated car, advertising a shoe business in North Berwick, took part in the 100th anniversary celebration. In the background is the Mount Pleasant Cemetery, and in the far distance is a barn; only the barn's foundation remains today.

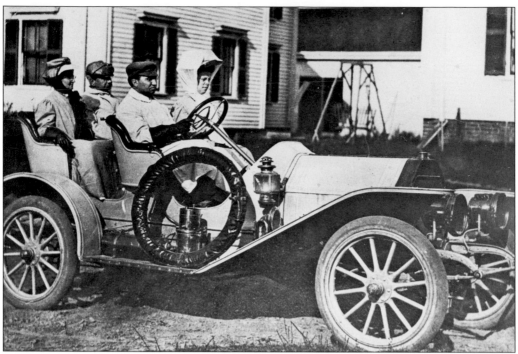

Orville Goodwin is driving a new car in this photograph. Note the ladies have their hats tied down with scarves in case the car picks up speed and risk their hats blowing away.

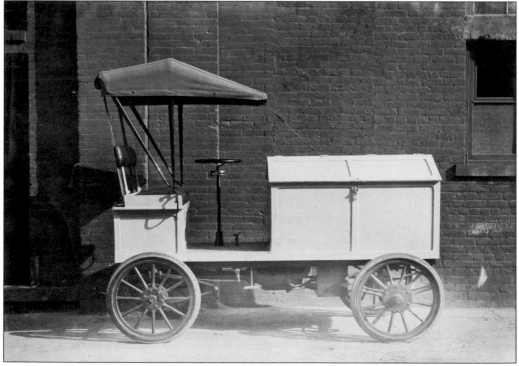

This picture of a homemade buggy makes one wonder what it would be like to drive this down a long hill!

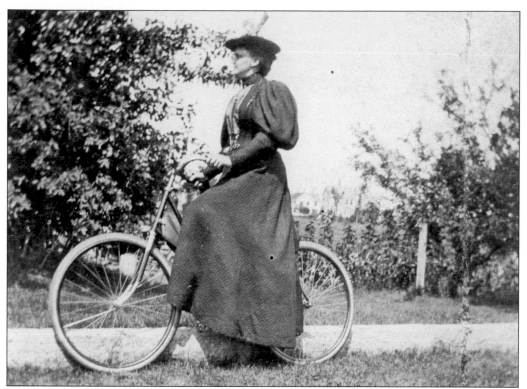

Margaret Hobbs is pictured here on her bicycle. Margaret was born in 1860. Cycling became the rage for women in the 1890s, so Margaret must have been in on this newfound "freedom" from the beginning.

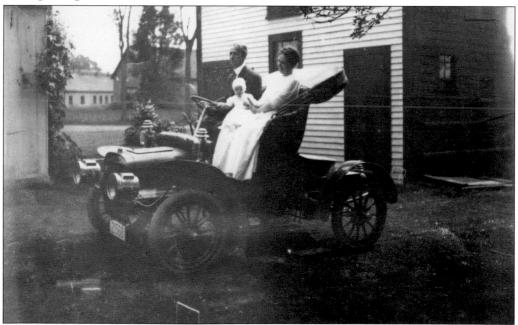

A family of three is photographed here taking a ride in a turn-of-the-20th-century car. In must have felt good to take a Sunday drive without having to hitch up the horses.

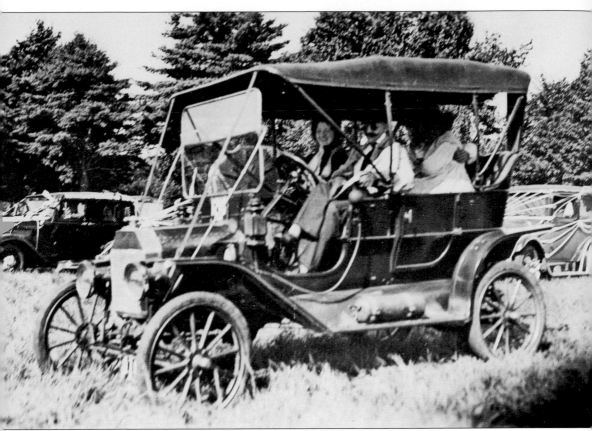

This picture is a beautiful example of a Model T. A simple, durable, and low-cost machine, the Model T was first produced on October 1, 1908. Fifteen million of these automobiles were sold in less than 20 years when Henry Ford watched the last one come off the assembly line in 1927. The Model T had an in-line four-cylinder engine and a top speed of 45 miles an hour and got as much as 20 miles to the gallon. Additionally, the engine was capable of running on gasoline, kerosene, or ethanol. Drivers also got exercise as the car was started with a hand crank; the electric starter was added in 1919. No one has ever proved that Henry Ford said, "You can paint it any color, so long as it's black," but that was the case. The first windshields were luxuries, there were no turn signals, and the headlights were fixed in place, making it difficult for oncoming traffic.

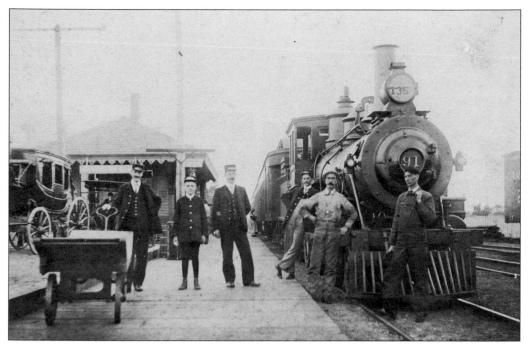

The train is parked at the North Berwick depot. Note the stagecoach to the left ready to take passengers to their destinations. Herbert Staples is second from the left. (Courtesy of Melissa Johnson Pierce.)

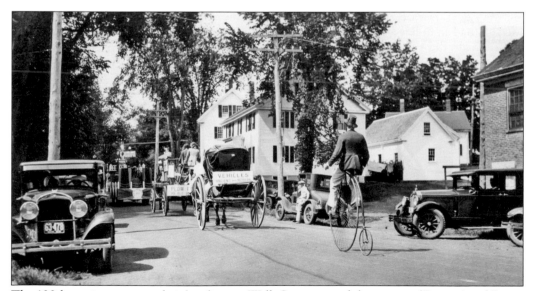

The 100th anniversary parade is heading up Wells Street toward the corner of Route 4 and Route 9. The high-wheel bicycle in the middle of the photograph was the first to be called a bicycle ("two wheel"). (Courtesy of June Guptill.)

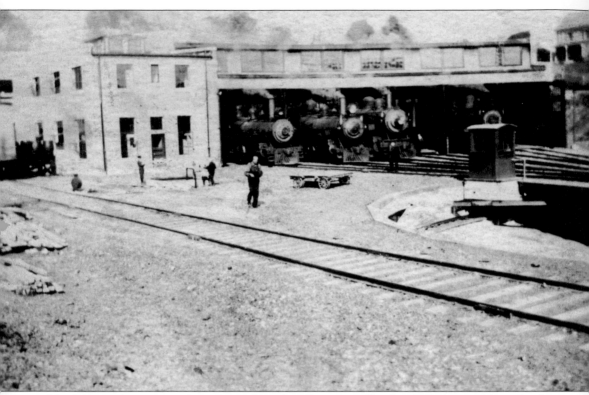

North Berwick was a very busy center for rail traffic, especially after 1873, as it was the only place in Maine where the tracks of the Western and Eastern Divisions of the Boston & Maine crossed. In the foreground of this roundhouse, part of the turntable can be seen where the locomotives were rotated for the return trip. Engines were also repaired or stored in the adjacent building. There are many wonderful stories about the North Berwick train depot—especially the story about its famous sponge cake. William Briggs and his wife ran a little restaurant near the train depot. In no time, Mrs. Briggs quickly became known for her superb cooking and baking and especially for her "lightweight, melt-in-your-mouth, sponge cake." While passenger trains made a 10-minute rest stop, many looked for refreshments at the Briggs. One of the most famous customers was British author Charles Dickens, who sent his aid to get a piece of the celebrated sponge cake for a 10-year-old named Kate Wiggins and himself. (Courtesy of Thomas Wellwood.)

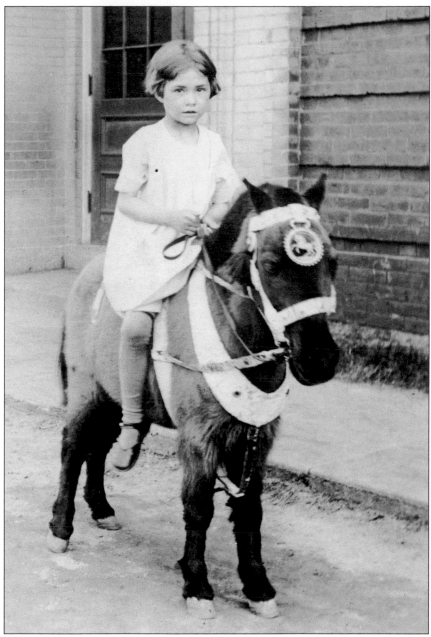

Children everywhere love ponies. In the farming town of North Berwick, many children were lucky enough to grow up with horses. Nevertheless, many parents were eager to have their children photographed on a pony when an itinerant photographer came to town. This picture is of Christine Welch on a pony, which likely belonged to just such a photographer. Traveling photographers visited neighborhoods for decades beginning in the 1890s, taking pictures of farms, families, and children in special poses, such as the one seen here. The children were so endearingly cute in this pose that every family wanted such pictures. In later years, some photographers provided additional props. Some even travelled with entire cowboy/cowgirl outfits, including vests, toy pistols, and holsters and chaps! In the 1930s, photographers made tintypes that were fast to produce, meaning that parents could purchase them on the spot. (Courtesy of Karen Summers.)

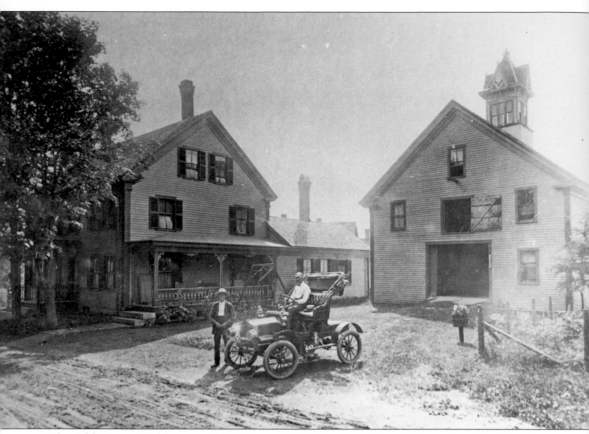

The Old Livery Stable, owned by George Furbish at one time, is located on Madison Street behind the Johnson's Funeral Home. A livery stable was where horses, teams, and wagons were for hire and where privately owned horses could be boarded. It was a necessary institution in every town for it provided a source of vital transportation as well as being a source of hay, grain, and coal. With the advent of the automobile after 1910, livery stables slowly disappeared. In the car is Brainard Drake, who lived in this house at the time of this picture. Drake is dressed in his finest with a bow tie and a straw hat sitting on the seat beside him. Straw hats were popular ware for hot summer days while riding in one's new Model T. Hats were fashioned with a solid or striped petersham ribbon around the base. College kids and alumni often wore their college's colors on their hat bands.

Nine

AROUND TOWN

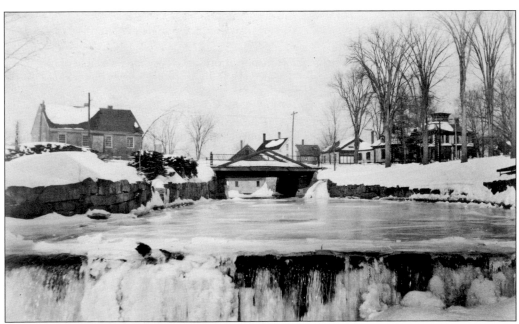

Here is a view of the lower dam near the Woolen Mill on the Great Works River. As one looks toward Wells Street and the old bridge, note the windows of the gristmill under the bridge. (Courtesy of Sherrilyn Lucas.)

This Federal period house on Wells Street was built by Haven Appleton Butler. He owned a thriving brick business in town, which provided millions of bricks to pave sidewalks, erect numerous structures, and build many fireplaces and chimneys in North Berwick. The house was torn down to make room for Triangle Motors. Today, Dunkin' Donuts and Subway occupy this spot. (Courtesy of Thomas Wellwood.)

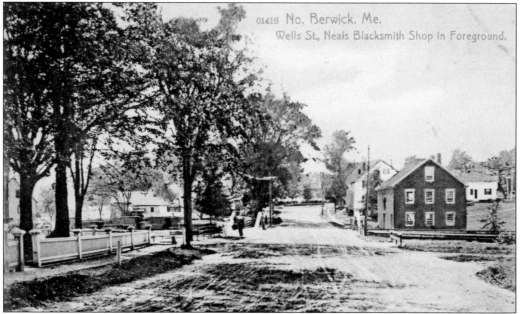

In 1811, Elijah Neal (1781–1857) built this bricks structure next to Doughty Falls as a blacksmith shop. Since then, it has been the site of many businesses, including a Tydol station (run by Buddy McGee), Curtis Goodwin's flooring store, a fabric store, and a flower shop. It is now owned by Merton Mathews Accounting. (Courtesy of Thomas Wellwood,)

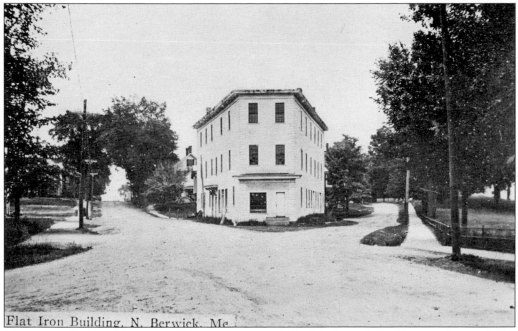

Flat Iron Building, N. Berwick, Me.

The Junior Order of American Mechanics erected the Mechanic's Building, nicknamed the "Flatiron Building" because of its shape, in 1877. It was used for town meetings for two years when, in 1879, the second floor collapsed under the weight, injuring many people. The building was torn down in 1969. (Courtesy of Thomas Wellwood.)

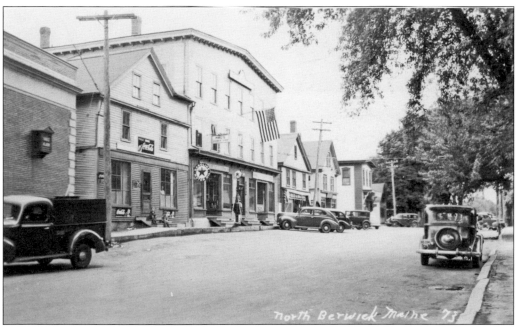

Part of Main Street is shown in this picture. The largest building is the Negutaquet Block, which housed the Improved Order of Red Men's fraternal organization. Looking closely, what appears to be a man standing is actually a Texaco gas tank on the sidewalk. Haven MacCrellis's barbershop was upstairs. Note the flag has 48 stars. (Courtesy of Thomas Wellwood.)

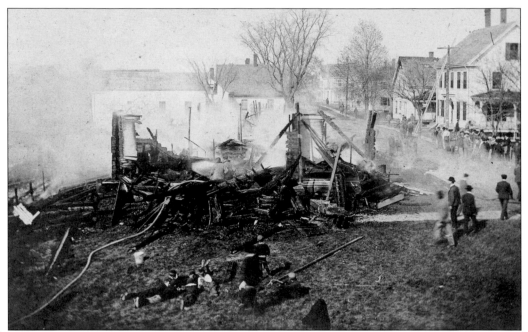

After the great fire of 1906, these were the remains of the oldest Baptist church in Maine. High winds drove the flames, which eventually claimed nine buildings. It is said that the church's bell "tolled all the way to the ground" as it fell. The swiftness of the blaze did not allow any valuables to be saved, including the Paul Revere communion set. (Courtesy of Thomas Wellwood.)

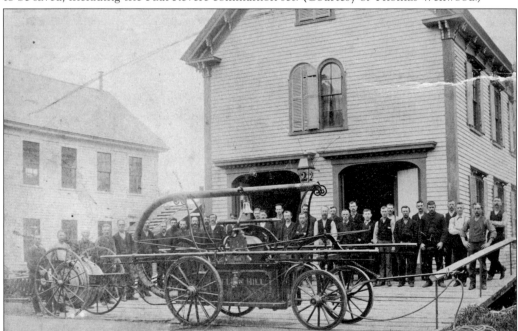

In 1883, the North Berwick Fire Department was established. Mary Hurd provided the funds to build the William Hill Fire Station for the town in 1927, and the former station, shown here, was moved to Portland Street to be used as a jail and later as a bottle shop run by Frank Wick. (Courtesy of William Wyman.)

This photograph is of the old Otis Johnson's place on Nowell Street. Otis Johnson and his wife, Lydia Morrill, were married on February 20, 1896. They had two children, Wesley and Ralph. According to the 1908 census, Otis was a butcher and Lydia a housewife. Nowell Street is likely named for the Nowell family who were at that time one of the prominent families in town. Originally, it was likely a dirt road that ran from the Nowells' farm to North Berwick center, a little more than a mile away. This was the way for a horse and wagon to take goods to market and pick-up what was needed from the stores in town, which included a pharmacy, coffee roaster, and feed store. The Nowells were not only farmers but were also great patriots, fighting in the Civil War and the Revolutionary War, including the Battle of Bunker Hill. (Courtesy of Thomas Wellwood.)

This house on the corner of Nowell and Elm Street was lived in for many years by Harland and Georgie Day. Harland owned a service station in the center of town along with the Flatiron Building across Main Street from his station. (Courtesy of Thomas Wellwood.)

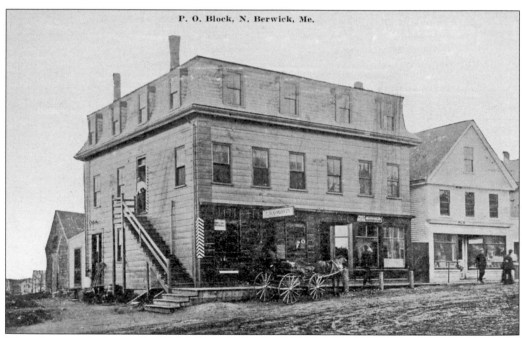

This photograph shows the C.W. "Candy" Goodwin Block. Goodwin's store and the post office are on the street level with George Varney's Barbershop above. Before that time, R.A. Parker's daily and weekly papers and periodicals were published here. Cressey's and Clark's five-and-dimes were other businesses to occupy the downstairs. Town Pizza is located here today. (Courtesy of Thomas Wellwood.)

Here, James McCorison's Men's Shop showcases metal for the war effort. A letter dated July 16, 1942, to the selectmen of North Berwick from the State of Maine reads, "The salvage campaign is now in full swing and I am again urging you to appoint a salvage chairman in your town, thus giving your community a chance to do its full share in the nation-wide program, on which war-production so vitally depends."

This is an early postcard of the D.A. Hurd Library. The first library in North Berwick was located in the fire engine house. Before that time, reading materials were kept in churches and home libraries of notable townspeople. Daniel and Mary Hurd's generosity, along with the commitment of the town's citizens, made this library a reality. It was dedicated December 31, 1927. (Courtesy of Thomas Wellwood.)

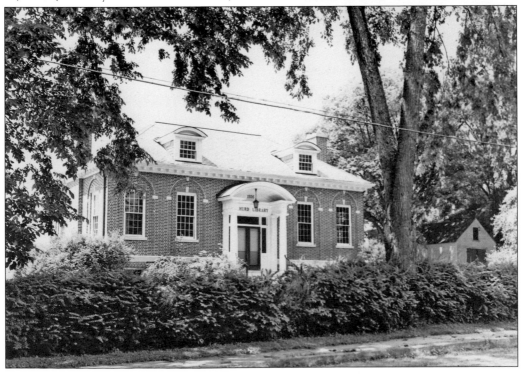

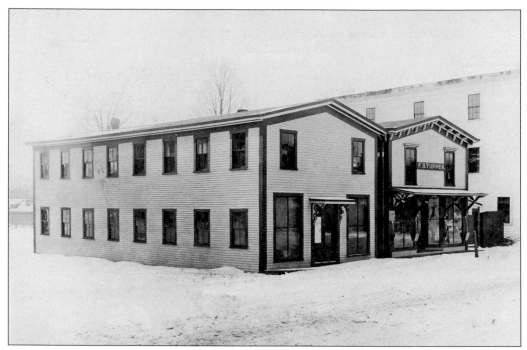

Two businesses on Main Street are shown here. For years, one was a grocery store and the other a hardware store. The closest structure is now home to the Legion hall, and the other, along with the Flatiron Building next to it, was torn down. (Courtesy of Thomas Wellwood.)

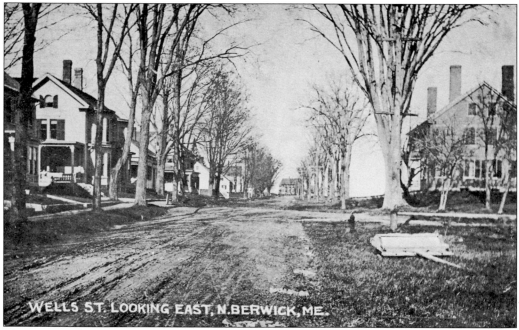

This view of Wells Street was taken in front of the Veteran's Triangle. The large brick house on the right is still there today, and the post office sits just beyond it. Note the road roller in the right foreground that was used to flatten the ruts in muddy roads before roads were paved. (Courtesy of Thomas Wellwood.)

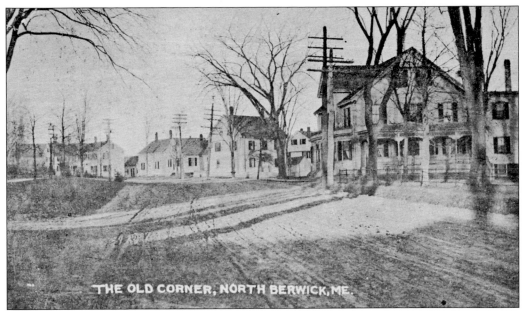

The old corner where Elm Street and High Street join is pictured here. The Hobbs Inn, seen on the right, was built between 1803 and 1806. According to Franklin Pierce Hall, by 1824 the inn served as a stagecoach stop and post office. In addition to an overnight stop, it provided a meeting place for political rallies, social events, and gossip. (Courtesy of Thomas Wellwood.)

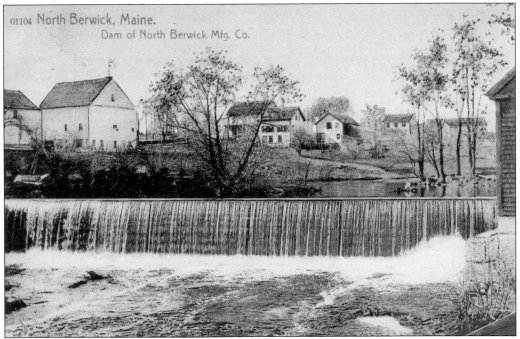

Doughty Falls, pictured above, is the main dam of five major dams in North Berwick. Records indicate that Thomas Doughty bought the property surrounding the Great Works River in 1657 and constructed a dam and a series of mills. This part of Greater Kittery, and then later Berwick, continued to be known as Doughty Falls until 1931, when it was incorporated as North Berwick.

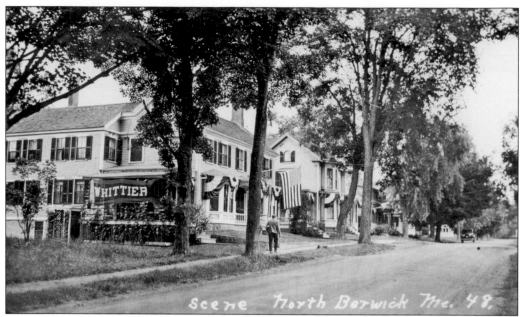

The Whittier House on Wells Street is decorated for the town's centennial. It burned in the late 1990s, and the space became part of Triangle Motors. (Courtesy of William Wyman.)

This picture has a view of Portland Street from the Route 4 end. These houses still stand today, but, of course, the road has been paved. (Courtesy of Karen Summers.)

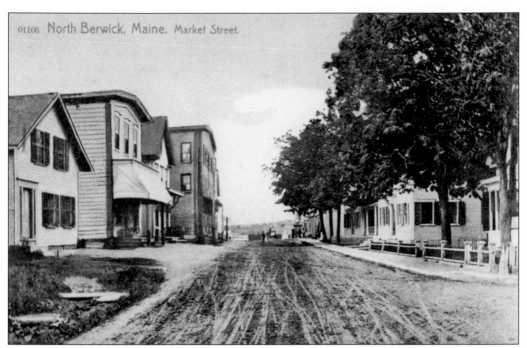

This photograph of Market Street was taken in front of Johnson's Funeral Home. The view is looking toward the railroad tracks.

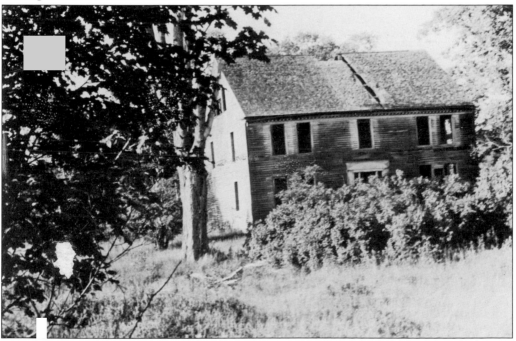

When this photograph was taken, this was all that remained of Governor Goodwin's house on Valley Road. It is now totally gone. Several notable Goodwins were born here, including two governors, Ichabod (governor of New Hampshire) and John Noble (governor of Arizona). Daniel Raynes Goodwin, who served as president of Trinity College in Hartford, Connecticut, and the ninth president of the University of Pennsylvania, was also born under this roof.

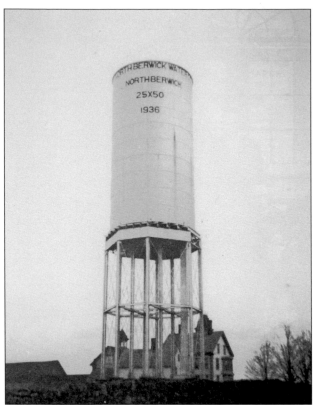

Pictured here is the old 200,000-gallon water tank on High Street that served the town for almost 100 years. It was dismantled in 1995 and replaced with a new 500,000-gallon tank on Lebanon Road. Note the Prescott house in the background.

After the original wooden school located here burned to the ground, noted architect Alvah T. Ramsdell of York constructed this school building in 1902. For many years, it housed kindergarten through high school. The last senior class to graduate from this school building was the class of 1947 when the high school moved to the new Mary Hurd School. In the early 2000s, the building was remodeled for town offices. (Courtesy of Thomas Wellwood.)

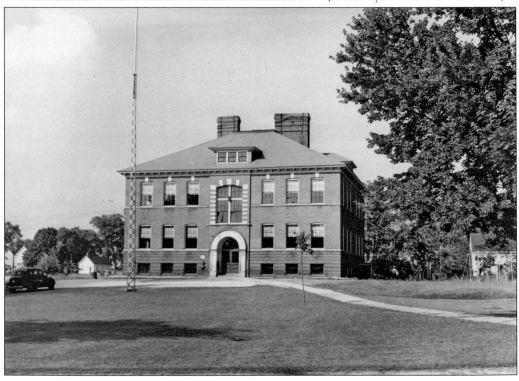

Ten

BUSINESS AND INDUSTRY

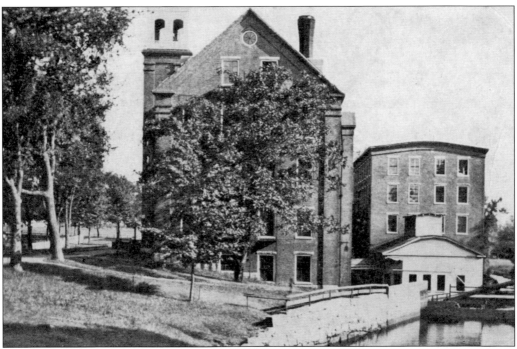

The Woolen Mill was constructed in 1862 after the original building burned. Mill looms were powered by one of the first steam engines in the country. Water was diverted into the basement via the dam and fed a boiler turning the water into steam. Blue woolen blankets for the Union army were woven here. Ralph Guptill remembers seeing different dye colors in the river while walking to school. The historical society has a display of blankets and the flag that flew over the building. (Courtesy of Thomas Wellwood.)

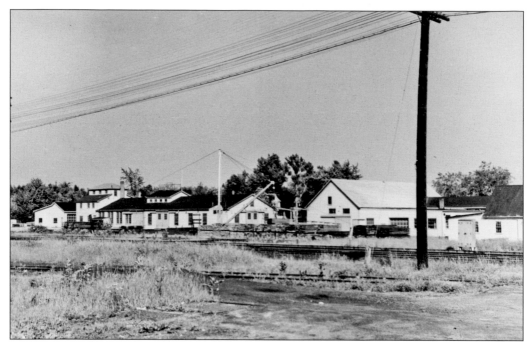

In 1835, William Hussey had the idea to make a plow out of cast iron rather than wood. This was the first product made by the company that became the Hussey Manufacturing Company and, eventually, the Hussey Seating Company. They have made stadium seating for venues such as Gillette Stadium and the Calgary Olympics. The history of this family and its diversified businesses has always been an asset to the town of North Berwick.

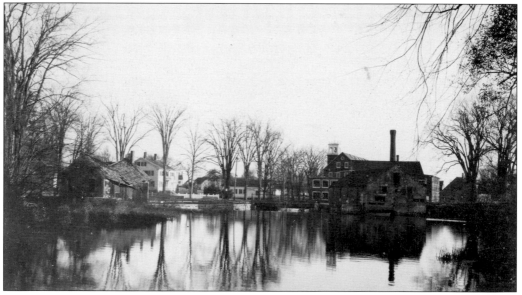

This photograph of the Great Works River was taken from above Doughty Falls. The old gristmill is on the left, and the sawmill is on the right. The Woolen Mill owned the dam and sawmill while it was in business. In the background are more Woolen Mill properties, including, from left to right, the superintendent's house, the counting house, and the mill itself. (Courtesy of Audrey Beals.)

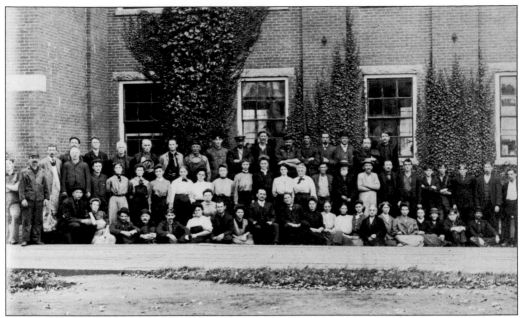

Pictured here is a large group of workers at the Woolen Mill. Peter Morrill, Thomas Stackpole, and John Lang founded the mill. The initial operation involved a few looms and 10 employees and produced custom blankets. In 1832, a partnership between Lang and William Hill formed, and by 1850, William Hill had full ownership of the mill and was its president. (Courtesy of William Wyman.)

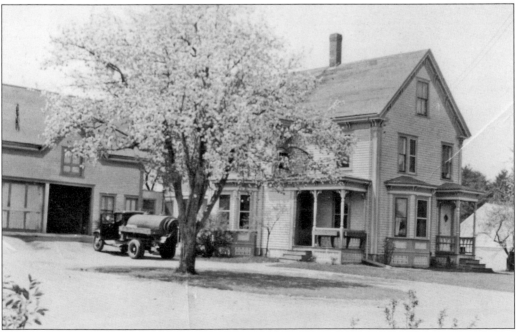

This house on Maple Street was built by Melvin Littlefield around the turn of the century. His son Roy Littlefield lived here when this photograph was taken, and the 1939 oil truck in the driveway was used to deliver oil to area customers. Large oil tanks stood across the road. Today, Thomas Littlefield is the fourth generation to own this home. (Courtesy of Thomas Littlefield.)

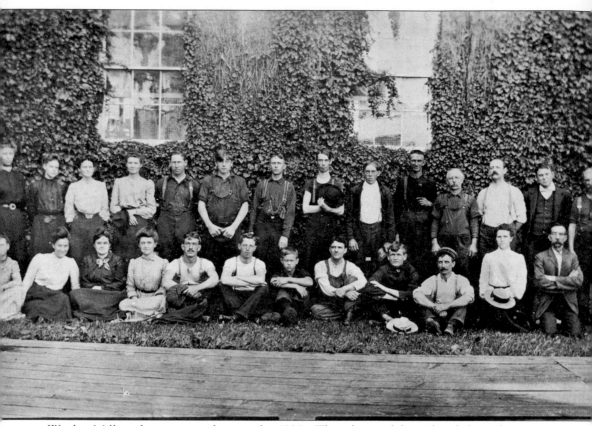

Woolen Mill workers are seen here in the 1900s. The advent of the railroad through town was a major factor in the growth of the mill. After the mill was destroyed in the great fire of 1861, William Hill rebuilt the structure with bricks from the North Berwick brickyard and lumber from the Bauneg Beg sawmill. It took only a year to complete the project due to the urgent needs of the Union army. (Courtesy of William Wyman.)

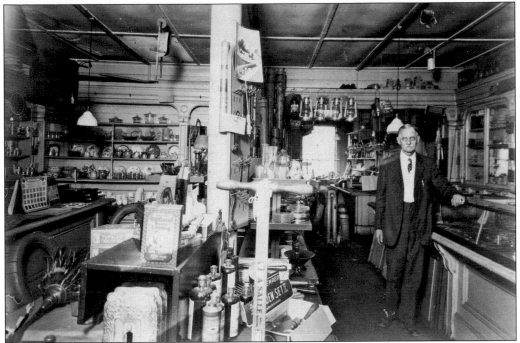

Nathaniel "Nat" Knight's Hardware Store was in the Negutaquet Block. He and his brother opened the store in 1918, and he continued to serve customers until his death at age 90. (Courtesy of Sherrilyn Lucas.)

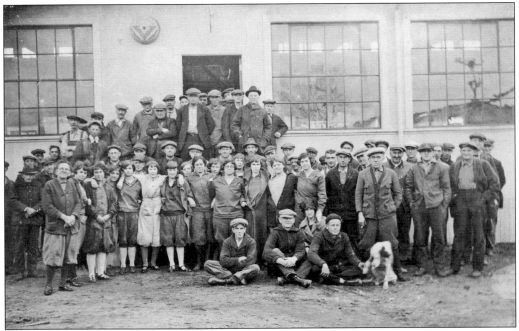

These mill workers are thought to be at the box mill on Buffum Road. This box mill was started in the mid-1800s by Issac Varney. During the late 19th century, women started to wear trousers and blouses for industrial work. Note the women in this photograph are wearing clothing more like pants than the cumbersome long skirts of the day.

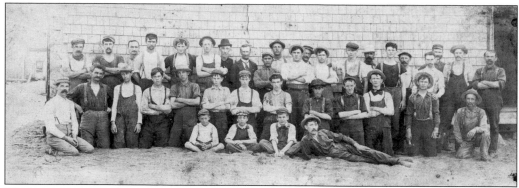

Workers are seen in this picture at an unknown location in North Berwick. Note the many young children. It was not until 1938 that Congress passed the Fair Labor Standards Act, which fixed a minimum age of 16 for work during school hours, 14 for certain jobs after school, and 18 for dangerous work. (Courtesy of William Wyman.)

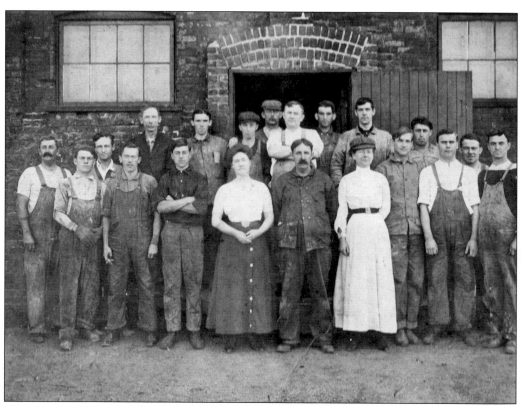

This picture shows a small group of Woolen Mill workers around 1910. Around 100 years before, in 1809, John Mayall signed a contract with Peter Morrill for a carding machine. It was the beginning of the machine wool industry in this town, an industry that lasted until 1955. (Courtesy of William Wyman.)

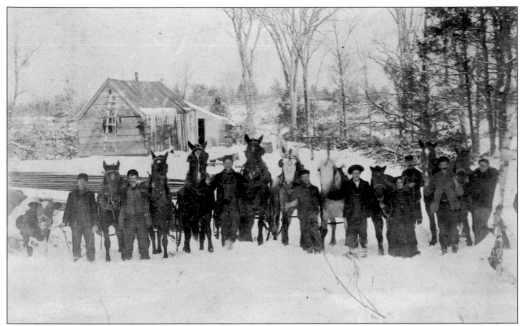

During the winter months on the farm, when the fields were frozen, the harvest focus turned from crops to timber. This group is likely a logging crew at the Brackett Hall farm. Loggers were often hired from Canada, and whole families would travel and set-up camps for the season. (Courtesy of Sherry Kojek.)

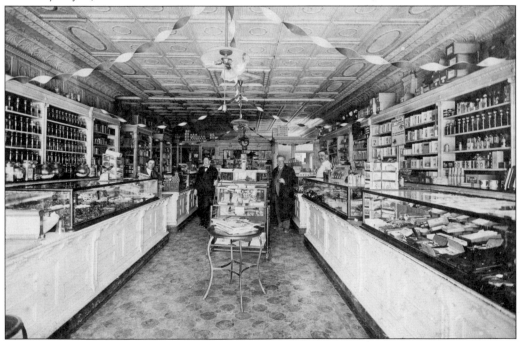

This picture is of Hurd's Apothecary, which was located in the Commercial Block. Over the years, the first story of this building housed a grocery store, a hardware store, a printing press, and a coffee roaster. Dr. MacCorison is third from the left. He graduated from Bowdoin College in 1878 and served as the physician in town from 1879 to 1923. (Courtesy of William Wyman.)

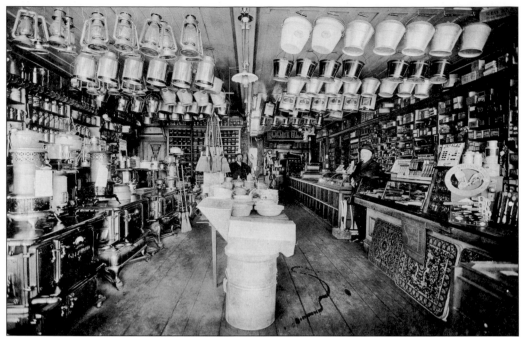

This is a photograph of a well-stocked hardware store in North Berwick. It is not known whose store this was or what building it occupied.

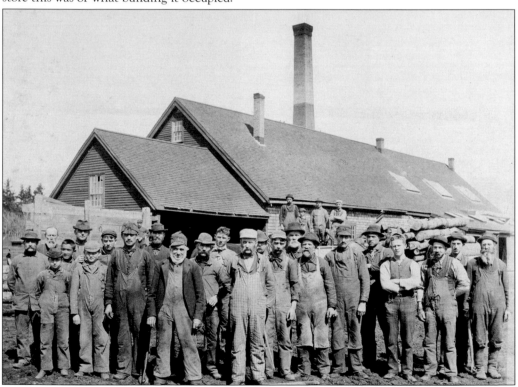

A large crew of workers is pictured here at Samuel Buffum's Box Mill. (Courtesy of William Wyman.)

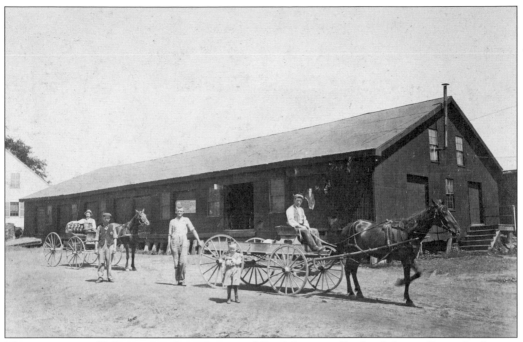

This picture is of Johnson Brothers Grain and Feed Store on Portland Street. It was built next to the railroad tracks for easy access. (Courtesy of William Wyman.)

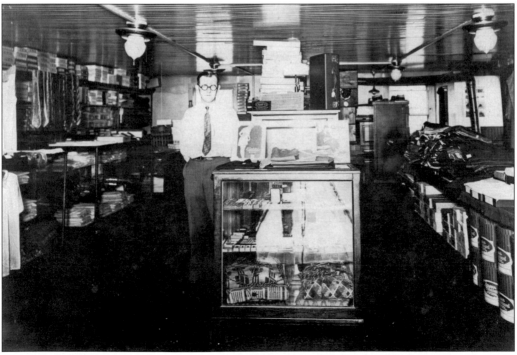

Shown here is James "Jim" MacCorison's Men's Store on Main Street. This sat where the Main Street Café is today. (Courtesy of William Wyman.)

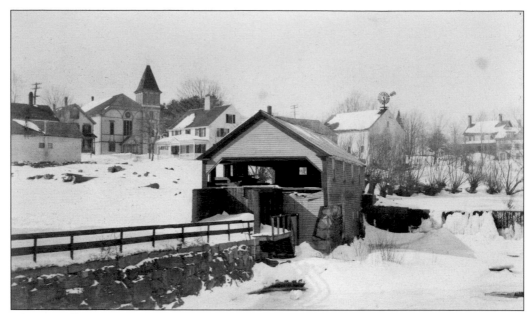

The sawmill at Doughty Falls is pictured here and was owned and run by the Woolen Mill. The sawmill stored piles of cut lumber in sheds. Note the weather vane in the background, made by the blacksmith Nathanial Knight for his barn. (Courtesy of Sherrilyn Lucas.)

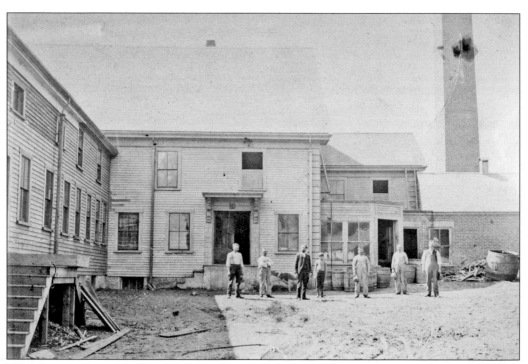

This photograph is of the Prescott Enameline and Blackening factory, which stood near the Quaker meetinghouse. J.L. Prescott and his son Amos started their successful venture on a woodstove in their barn on High Street. In the coming years, they revolutionized the business with a new line of stove blackening and shoe polish. (Courtesy of Thomas Wellwood.)

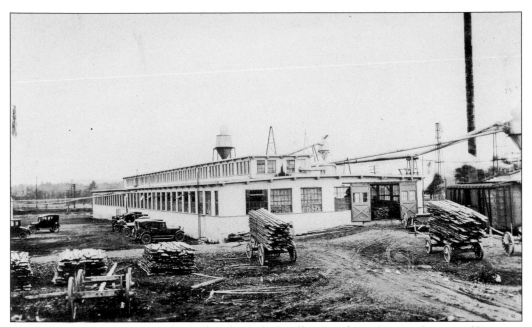

The box factory seen here was located at the end of Buffum Road near Varney Crossing. (Courtesy of William Wyman.)

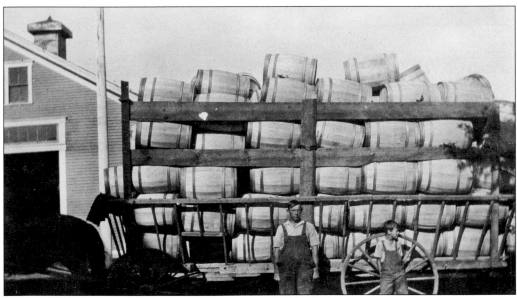

This wagon is full of barrels probably waiting to be delivered to the railroad station. The small boy is Cecil Chadbourne with his father, Wilbert Chadbourne. (Courtesy of Andrea Lovell.)

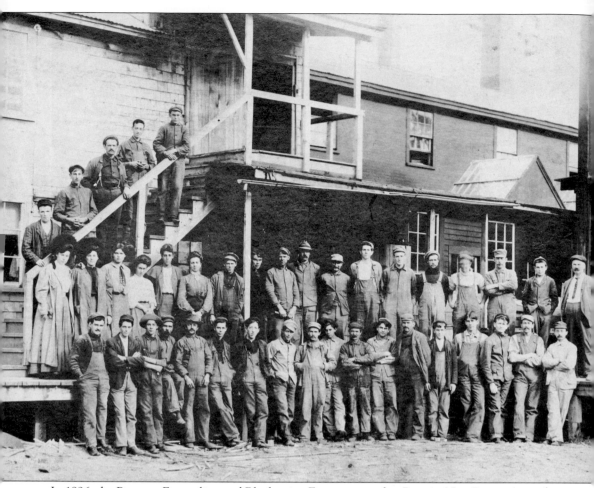

In 1896, the Prescott Enameline and Blackening Factory moved to Passaic, New Jersey. According to the back of this photograph, in the first row are Otis Littlefield, third from left, and H. Edwin Hayes, far right. Second from the bottom at the steps is Joseph Goodwin, and fifth from the left in the second row is Anna Goodwin Sillon. (Courtesy of Melissa Johnson Pierce.)

Pictured here is a switchboard operator at a phone company behind the old bank. Before the 1960s, operators connected calls by inserting a pair of phone plugs into jacks. In the late 1890s, operators often served the same small group of customers and not only knew their patrons' voices but were also often wonderful sources of the latest news, weather, sports results, and town gossip. (Courtesy of Melissa Johnson Pierce.)

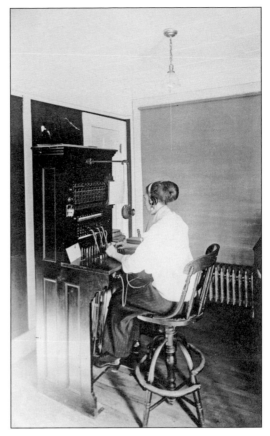

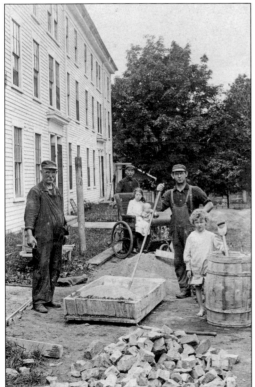

David and Sid Nutter are working to build steps for the North Berwick Company Mill Block. Apartments here were lived in by the Woolen Mill workers. It was torn down a few years after the Woolen Mill went out of business. Pearl Lincoln is the girl in the wheelchair.

Discover Thousands of Local History Books
Featuring Millions of Vintage Images

Arcadia Publishing, the leading local history publisher in the United States, is committed to making history accessible and meaningful through publishing books that celebrate and preserve the heritage of America's people and places.

Find more books like this at
www.arcadiapublishing.com

Search for your hometown history, your old stomping grounds, and even your favorite sports team.